IMAGES
of America

NORTHERN
CALAVERAS COUNTY

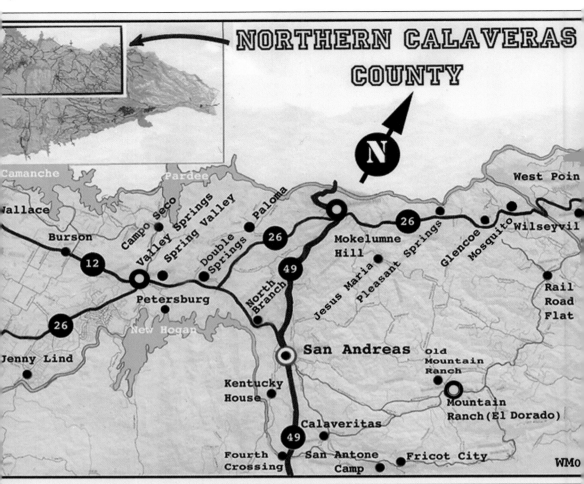

NORTHERN CALAVERAS COUNTY

Camanche Pardee West Poin
Wallace
Burson Campo Seco Valley Springs Spring Valley Double Springs Paloma 26 Mokelumne Hill Pleasant Springs Jesus Maria Glencoe Mosquito Wilseyvil
12 49 North Branch 26
Petersburg New Hogan Rail Road Flat
26
Jenny Lind San Andreas Old Mountain Ranch
Kentucky House Mountain Ranch (El Dorado)
Calaveritas
49
Fourth Crossing San Antone Camp Fricot City WMO

Nestled between the fertile San Joaquin Valley to the west and the towering Sierra Nevada to the east, Northern Calaveras County straddles the historic Mother Lode, marked by Highway 49. The region sits little more than an hour's drive southeast of Sacramento and two hours east of San Francisco. (Map created by Wally Motloch.)

ON THE COVER: Whether mining, logging, ranching, or farming, the pioneers of Northern Calaveras valued the land and hard work. This c. 1900 photograph shows a threshing crew in the Burson–Jenny Lind area. (Courtesy Calaveras County Historical Society.)

IMAGES
of America

NORTHERN
CALAVERAS COUNTY

Judith Marvin, Julia Costello,
and Salvatore Manna

ARCADIA
PUBLISHING

Published by Arcadia Publishing
Charleston, South Carolina

Printed in the United States of America

Library of Congress Catalog Card Number: 2007924271

For all general information contact Arcadia Publishing at:
Telephone 843-853-2070
Fax 843-853-0044
E-mail sales@arcadiapublishing.com
For customer service and orders:
Toll-Free 1-888-313-2665

Visit us on the Internet at www.arcadiapublishing.com

Northern Calaveras County was born from the Mokelumne and Calaveras Rivers, grew with the gold found in its waters, and matured with the natural resources and recreation granted by its streams and reservoirs. (Courtesy Calaveras County Archives.)

CONTENTS

ACKNOWLEDGMENTS

The photographs, maps, images, and information for this publication have been gleaned from several sources, including the Calaveras County Archives, Calaveras County Historical Society, Mokelumne Hill History Society, Society for the Preservation of West Calaveras History, private individuals, and the files of the authors. Of great assistance were the unpublished archeological and historical studies conducted for the Calaveras County Planning Department, California Department of Transportation, Pacific Gas and Electric Company (PG&E), the Army Corps of Engineers, East Bay Municipal Utility District, and other entities and individuals for whom the authors have worked.

Many individuals assisted in this publication, particularly Paula Leitzell and Carolyn Wagner (Chapters 3 and 4) and Pat McGreevy and Don Ames (Chapter 7). Willard P. Fuller Jr. clarified the county's complex geology, while Calaveras County archivist Shannon Van Zant and Calaveras County Historical Society historian Cate Culver generously opened their archives to us. As always, photographer Wally Motloch did an exemplary job in scanning the images, while Terry Brejla carefully edited the text. All funds generated from the sale of this book will be distributed to the above-noted historical societies and archives, to whom we are grateful for preserving the threads of the region's historic fabric.

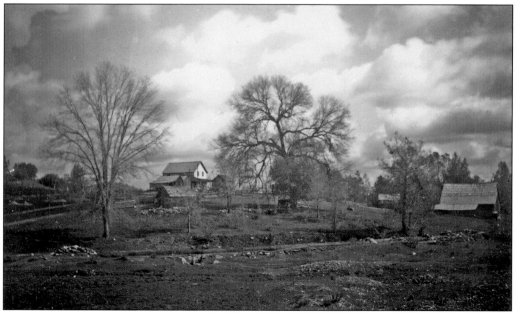

Picture-postcard ranch life in Northern Calaveras County includes the serenity of historic homesteads and their stone fences enclosing gardens and pastures. (Courtesy Calaveras County Archives.)

INTRODUCTION

The land that is Northern Calaveras has been home to humans for more than 12,000 years and for the Central Sierra Mi-Wuk for about 700 years. The region was overrun by argonauts after the discovery of gold on the American River in January 1848. Hordes of gold-seekers from Mexico, South America, Europe, Asia, the Hawaiian Islands, Europe, the United Kingdom, and virtually every state in the union descended upon the California foothills. Calaveras County's people—ethnically diverse from the beginning—by 1860 were 22 percent Chinese, with Chileans, Mexicans, Germans, Italians, Irish, French, English, and other immigrants making up a large portion of its population and naming various geographic locations.

One of California's original 27 counties, Calaveras has had five county seats; the first named, but not established, was at Pleasant Valley, about one and a half miles west of Jenny Lind, in February 1850. That honor went to Double Springs, where the first county officers were elected in April of that same year. In 1851, however, both Jackson and Mokelumne Hill petitioned for an election to move the county seat, and after much wrangling, it was established at Jackson. By 1852, however, Mokelumne Hill had become much larger than Jackson, and the county seat was again moved. (Jackson becoming the county seat of the newly formed Amador County in 1854.) There it remained until, with the decline of gold production in the Mokelumne Hill area in the 1860s, and due to its distance from the southern half of the county, voters selected San Andreas as the new county seat. In 1867, a new courthouse and jail were completed, and with the move, county officers, attorneys, and many professional people relocated to San Andreas, changing the demographics of the county forever.

As the century progressed, some Gold Rush settlements became villages and then towns, while others disappeared. Churches and schools were established, and community and fraternal organizations flourished. Neat frame houses and brick and stone commercial buildings replaced the tent cities of the miners. Hotels and inns, general merchandise stores, tin and carpenter shops, boot and shoe shops, liveries, and the ubiquitous saloons lined the main streets.

For over half a century, mining provided the cornerstone for the local economy, with all other enterprises its stepchildren: water, logging, ranching, farming, commerce, industry, and power. First finding gold along the streams and rivers, miners quickly worked their way up to its source in the quartz veins of the Mother Lode. Placer mining gave way to hard-rock mining during the late 1880s and early 1890s with the advent of the second Gold Rush. The mines closed during World War I and had a small boomlet during the 1930s Great Depression. Virtually all the mines closed when World War II began, and they have seen only sporadic activity since.

Water has always been one of the most important resources in the area, with its transportation a major economic enterprise. Beginning in 1852, the Mokelumne Hill Canal and Mining Company brought water through a system of canals, ditches, flumes, and drainages to virtually every mining district downstream from its takeout on the South Fork of the Mokelumne River—a system that continues in part today as the Calaveras County Water District. Other ditches brought water from the Calaveras River and San Antonio Creek to Mountain Ranch, Calaveritas, San Andreas, and points in between.

Reaping the benefits of the ditch and flume systems, agriculture began to play a more important role in the local economy after the initial gold discoveries. Family orchards, vineyards, truck

gardens, wineries, and breweries had become omnipresent by the 1860s, supplying the needs of the burgeoning communities. Livestock, however, has always provided the backbone of the agricultural industry, with the practice of transhumance opening up the high country to cow and sheep camps.

As Native American trails were superseded by stage and wagon routes, roads became increasingly important after the advent of the automobile and eventually became State Routes 49, 12, and 26. The San Joaquin and Sierra Nevada Railroad, completed to Valley Springs in 1885, provided the impetus for the development of the lands in Western Calaveras County as settlers flocked to the area on the easy transportation route.

Up-country, the need for timber for the flumes, shafts, adits, and head frames of the mines and lumber for buildings continued sporadically, reaching its peak in the years immediately following World War II, when California experienced a surge in population and development. Company towns were established and logging trucks penetrated the high country.

For many years Calaveras slumbered, but beginning in the 1920s and continuing to the present, water storage and hydroelectric generation began to play a major role in the economy. Of prime importance was the establishment of the Calaveras Cement Plant in 1927, the largest employer in Calaveras County for over 40 years. That year, the rail line was extended to the San Andreas plant to carry cement to the construction yards of Pardee Dam, helping to create one of the three reservoirs (along with New Hogan and Camanche) that today still provide agricultural and domestic water to the Central Valley and Bay Area, and comprise the Tri-Dam recreational region.

Having retained its essentially agrarian and rural character, Calaveras today has once again become a magnet for immigrants—this time people from the cities who desire a lifestyle more rooted in the natural landscape. Calaveras, like the other counties in the Mother Lode, is experiencing an era of development and growth unprecedented since the Gold Rush.

One

SPEAKING THE SUN UP

I remember seeing Chief McKenzie speaking to the people, standing at the top of the hill and looking toward the sun. He would speak for hours and hours until he was so hoarse he could no longer speak. People would come and go, stay and listen for a while. The fandangos lasted two to three days.

—Robert McKisson

Robert McKisson recalled gatherings at the village of Apautawilu, next to his family's ranch at Pleasant Springs. Other early records recount the Mi-Wuk practice of "speaking the sun up" at ceremonies.

Recent archaeological studies have identified the presence of people in Calaveras County as many as 12,000 years ago. More abundant evidence exists, however, for the relatively recent residents of the last 2,000–3,000 years. These people, descendants of ancient Great Basin tribes, are identified by distinctive projectile points, rock art, burial practices, and food technologies. Somewhere between 500 and 1,000 years ago, the Northern Mi-Wuk arrived in the area, often settling on sites occupied by their predecessors. It was the Mi-Wuk who intensified use of the acorn as a staple food and utilized milling stations with multiple grinding holes. They lived in tribal groups identified by family lineages, and moved seasonally through elevations in their territories. Oriented to watercourses, the Mi-Wuk of the Mokelumne River inhabited villages in both modern Amador County and Calaveras County.

Mi-Wuk villages are known to have been located around Mokelumne Hill, in Happy Valley and Chile Gulch, at Pleasant Springs and Sandy Gulch, in San Andreas, West Point, and other locations. With the discovery of gold in 1848, the Sierra Nevada foothills were quickly overrun by gold seekers who appropriated both the water and the land of the Mi-Wuk. Game virtually disappeared, and most Mi-Wuk were forced out of their favorable village locations to more remote sites. The population was decimated by introduced diseases and loss of their food sources. Surviving in settlements around modern West Point, the modern Mi-Wuk still maintain strong links to their ancestral past.

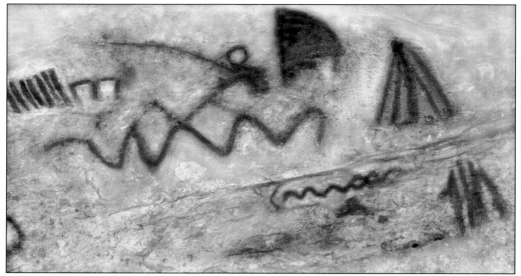

Petroglyphs (designs pecked or carved into rock surfaces) and pictographs (rock paintings) can be found in caves and rock shelters in the Sierra Nevada foothills. The meanings of the design elements are not known but may be linked to Mi-Wuk, Maidu, or Great Basin traditions. This design is from a small, once-inhabited rock shelter near the Mokelumne River; it has been digitally enhanced to bring out the faint designs. (Photograph by Sal Manna; courtesy Society for the Preservation of West Calaveras History.)

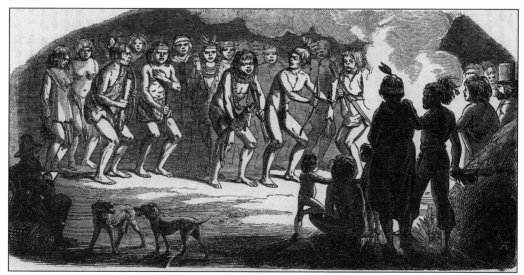

The most important ceremonial dances of the Central Mi-Wuk were called "Big Times," celebrations that were held for various reasons and at different places throughout the year. The events often lasted for several days and featured dancing, hand games, and plenty of food. These large gatherings provided opportunities for religious renewals as well as socializing with neighbors and kin. (*Hutching's California Magazine.*)

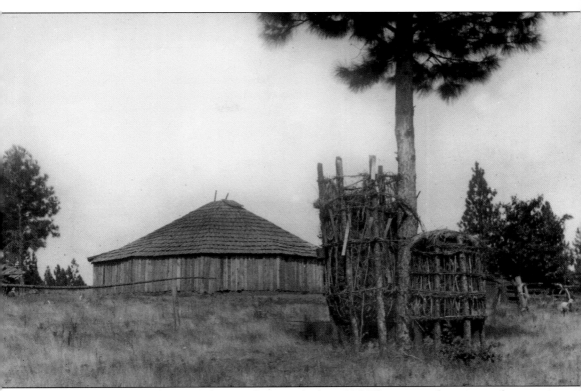

The large roundhouse at Rail Road Flat was photographed in 1906. These semisubterranean dance houses were characteristic of the Mi-Wuk and were used for social and ceremonial gatherings. A foot drum opposite the entryway marked where the singers congregated; a fire pit was located in the center with a smoke hole overhead, while the floor where the spectators sat was covered in pine needles or sedge. In the foreground of the photograph is an acorn storage granary. Current celebrations in Northern Calaveras are held at the roundhouse near West Point. (Courtesy Hearst Museum of Anthropology.)

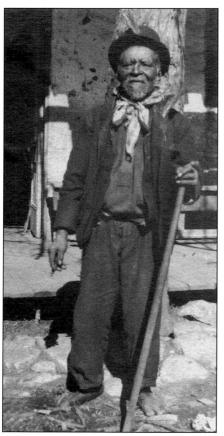

Kanaka, also known as Kanaka Bob, was a Mi-Wuk who was a frequent visitor in the town of West Point around 1890. Like many of the Mi-Wuk, he formed close associations with the local settlers and was regularly employed on their ranches. He died at the County Hospital in 1909. As Kanaka is a term for a native Hawaiian, perhaps he was descended from a Gold Rush miner from the islands. (Courtesy K. Smith.)

This mortar complex at Upper Rich Gulch was photographed in 1906, with Mi-Wuk Chief "Captain" McKenzie demonstrating its use. Of the many vegetable foods used by the Mi-Wuk, acorns were the staple. Harvested in the fall, they were stored in granaries for many months and freshly ground in mortars when needed. The flour was leached of acids by repeated flushings of water. (Courtesy Hearst Museum of Anthropology.)

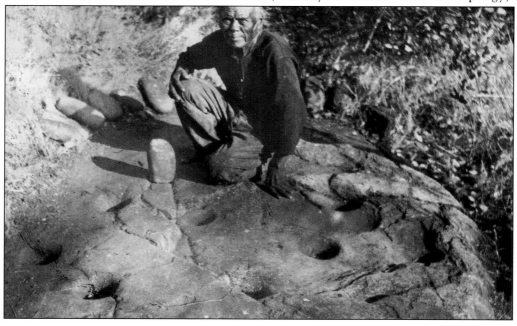

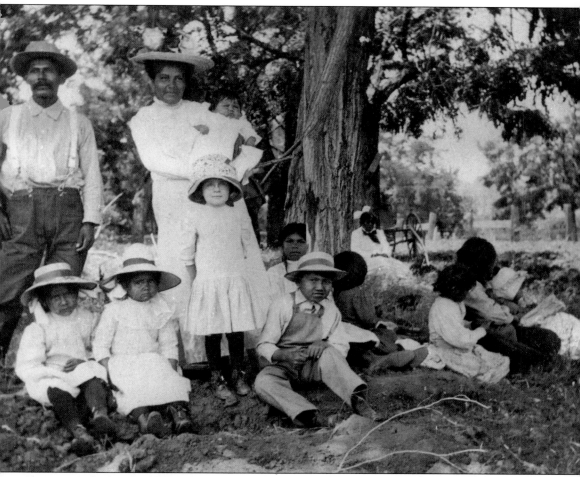

About 1913, the family of John and Addie Polo Eaph was photographed at a picnic at the West Point School ball field. Those in the portrait include their daughters Rowena, Edna, baby Virginia, and son Wilber. The daughter of the photographer is standing in the center front. Eaph descendants still reside on the family land on Bummerville Road. (Courtesy Virginia Eaph.)

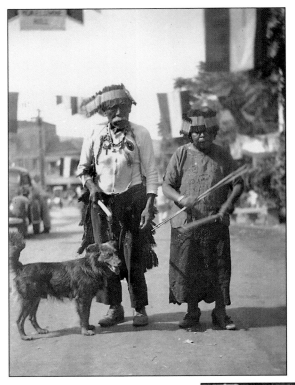

The O'Connors were both Northern Calaveras Mi-Wuk; Pedro may have originally been from the Mokelumne Hill area, while Lily's father was from Sandy Gulch. By 1928, the couple was residing at Big Bar on the Mokelumne River (the Highway 49 crossing), where they lived for many years, holding various jobs throughout their lives. Pedro was a spokesman for his people, served as a doctor at ceremonies, and was a superb dancer who taught young boys these cultural traditions. (Courtesy Dell'Orto/Fischer family.)

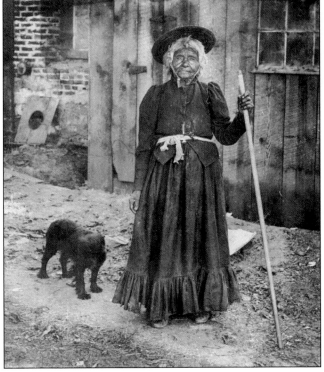

Manuella Jesus, reputedly a descendant of Chief Moquelumne, was born in the Native American village at Happy Valley. Her first husband, Jesus (Hasuche), was educated at Mission Santa Clara and died in 1849. Her second husband, Captain Billy, was murdered by his tribe in 1858 for misdeeds. As the daughter of Chief Indian Jack, Manuella was a prominent presence around Mokelumne Hill and a strong political figure in her tribe. Referred to as "Queen" Manuella, she died in about 1910 at over 100 years of age. (Courtesy Calaveras County Historical Society.)

After the death of Chief Indian Jack, his eldest son, Captain Jack, became chief of the Mi-Wuk near Mokelumne Hill. He held this position until his death around 1905. While Mi-Wuk gatherings in the 1850s attracted some 1,500 participants, by 1915 less than 25 were left. In this photograph, Captain Jack and his sister Manuella Jesus are demonstrating the use of grinding mortars in about 1900. (Courtesy Calaveras County Historical Society.)

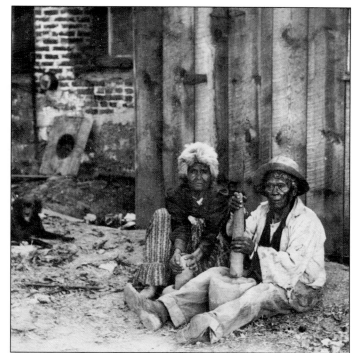

Dan Carsoner was born on the family ranch at Skull Flat near West Point in 1909. He was the son of woodchopper Tom Carsoner and Rosie George, a Mi-Wuk from Rail Road Flat. Tom's parents were William Carsoner, a native of Kansas and a gold-mining forty-niner, and his Mi-Wuk wife, Mary Ann (Chalk-e-yet), daughter of Wotoko and Milla. This photograph of Dan was taken about 1930, after he had returned from the Native American school in Plumas County. (Courtesy Calaveras County Archives.)

Known as Indian Eaph, Captain Eaph, and Eaph Cummings, Eaph was interviewed by the University of California, Berkeley, ethnographers C. Hart Merriam and A. L. Kroeber in the early 1900s, providing them with much information regarding the Mi-Wuk language and way of life. This photograph was taken by them in 1903. Residing first at Sandy Gulch, Captain Eaph and his wife, Mary Ann (Chalk-e-yet; earlier married to William Carsoner), moved to West Point and then Bummerville, where they built a community roundhouse (now gone) near where their descendants live today. (Courtesy Hearst Museum of Anthropology.)

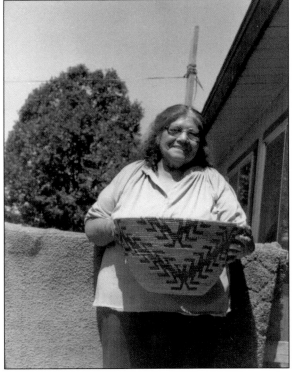

Virginia Eaph, the granddaughter of Captain Eaph, is pictured in 1986 at her home in West Point with one of her mother, Addie's, baskets. Residing in a log and wood frame cabin in the 1910s, Addie still ground acorns in a bedrock mortar but cooked meals in a modern wood-burning stove. She was the last in her family to practice the traditional art of basketry. (Photograph by Julia Costello.)

Two

RICHES FROM THE EARTH

Placer gold was first found in Calaveras County in 1848 along the banks of the Mokelumne, Calaveras, and Stanislaus Rivers and in innumerable creeks and drainages. In Northern Calaveras, towns such as Mokelumne Hill, Chile Junction, Campo Seco, West Point, and San Andreas quickly sprang up around the major strikes. Remains of extensive placer mining carried out during the early years of the Gold Rush may still be seen along the county's drainages, creeks, and rivers.

It was not until the mid-1850s that gold was discovered in the quartz veins in Calaveras County, prompting another boomlet in the area. While there was intermittent activity through the 1860s and 1870s, hard-rock mining did not flourish until the late 1880s. At this time, advances in mining and milling technologies and the availability of capital from the Eastern United States and foreign countries combined to stimulate large-scale underground mining. Although not a consistent employer, the industry experienced several significant revivals, particularly in the late 19th century and again in the early 20th. Placer deposits were exploited once more by the early 1900s when mechanical dredging of placer beds in western areas of the county commenced. In addition to successful extraction of gold ore, copper was king at the Penn Mine, while limestone deposits fed the Calaveras Cement Plant for nearly a half century.

Mining accounted for the location and names of many towns and communities that either developed where major strikes occurred or sprang up as supply camps to provide for the nearby miners. Paloma was named for the nearby Paloma mine (later renamed the Gwin), while "Mokelumne (on the) Hill" distinguished the town's location from the rich diggings on the adjacent river. Rich Gulch, Campo Seco, Boston-Yale, Poverty Bar, Big Bar, Middle Bar, and others all reflect mining associations. San Andreas was named for the Mexican church established there, while other communities took their names from events, locations, individuals, or geographical features.

Until recent times, socioeconomic development in Northern Calaveras has occurred primarily within the context of the mining industry. Not only did mining lead to the formation of the county in 1850, it served as the linchpin of the local economy for nearly a century thereafter. Transportation, lumbering, water, power generation, and ranching have all been directed and influenced by the mining industry.

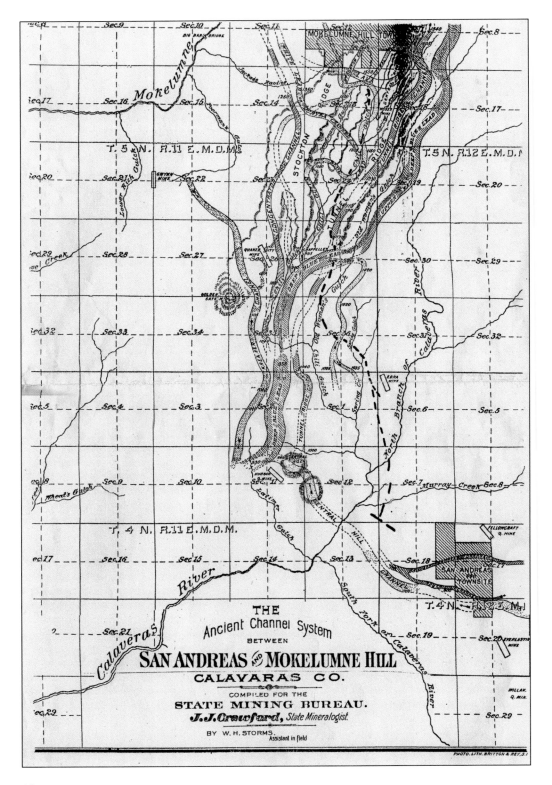

THE
Ancient Channel System
BETWEEN
SAN ANDREAS AND MOKELUMNE HILL
CALAVARAS CO.
COMPILED FOR THE
STATE MINING BUREAU.
J. J. Crawford, State Mineralogist.
BY W. H. STORMS,
Assistant in field

OPPOSITE: Extending from the western Central Valley to almost the Sierra Nevada crest, the landscape of Calaveras County changed dramatically throughout its geologic history. About 400 million years ago, mountains to the west eroded their sediments into a large sea that stretched eastward into Nevada. Then thick volcanic flows poured out of fissures, producing layers that later emerged as the county's distinctive "tombstone rocks." Subsequent continental plate movements created much folding and faulting, pushing up the current Sierra Nevada range. Far beneath the surface, molten granite intruded into the fault zone and as gold-bearing quartz filled the smaller fissures the Mother Lode was born. Rapid erosion wore down the early Sierra Nevada while the ancient Calaveras River exposed and ground up the gold-bearing quartz veins. "Free" gold was carried downstream, settling out in placer deposits along the various old channels (pictured). About 60 million years ago, new generations of rivers were formed by the dramatic uplift of the new Sierra Nevada range. The youngest of these, the current Mokelumne River, cut through the landscape, excavating deep canyons and ravines. The Mokelumne also carried off free gold from the old Calaveras River channel placers, depositing it into new pockets of wealth to be discovered by the Gold Rush miners.

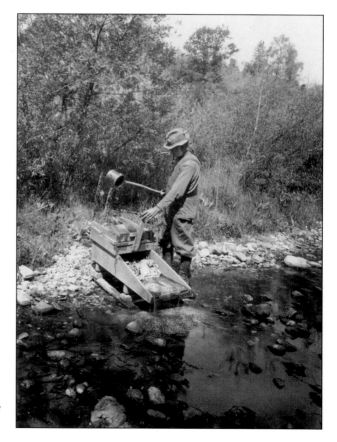

The cradle, or rocker, is one of the simplest mining tools and can be operated by one individual. Named for its likeness to a baby cradle, it is essentially a wooden trough with a screened hopper on top and a handle that allows the operator to rock the device. Gold-bearing gravels are dumped into the hopper and enough water poured in to carry the lode across a series of riffles. "Paydirt" caught behind the riffles was periodically cleaned out and panned. (Courtesy Calaveras County Archives.)

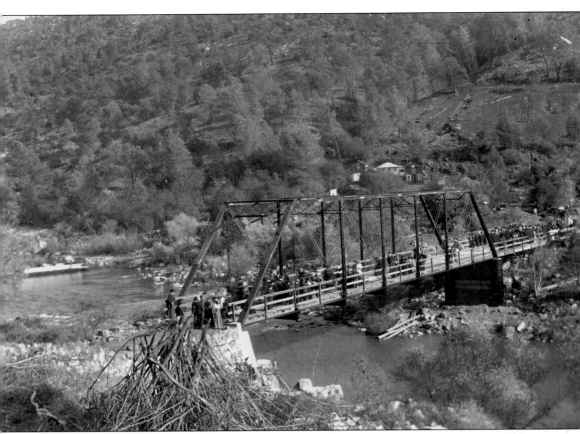

Much of the early placer gold was recovered from "bars" along the rivers where gold-bearing gravels had settled out at slack locations. Generally submerged, these rich deposits were worked after turning the river out of its course with wing dams and diversions. In the spring of 1848, Col. Jonathan Stevenson and about 100 of his men began working the Middle Bar of the Mokelumne River, which soon became an important crossing, first by ferry and then a series of bridges. The bridge depicted here was dedicated in 1912. (Courtesy Calaveras County Archives.)

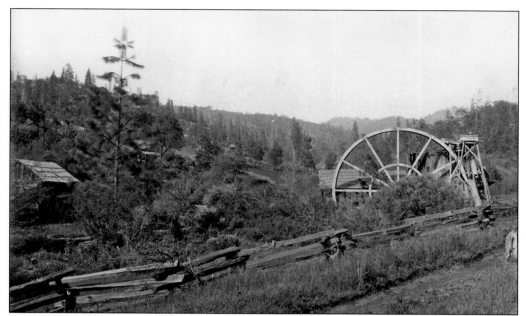

One of the primary sources of power for early mills was the water wheel, seen here, which was relatively simple to build and operate. Requiring only a small flow of water with little head (pressure), these devices were attached to arrastras, Chile mills, stamp mills, and many other types of power-driven crushers. The large wheels in neighboring Jackson were used to carry tailings from the Argonaut millsite to a holding pond. (Courtesy Calaveras County Archives.)

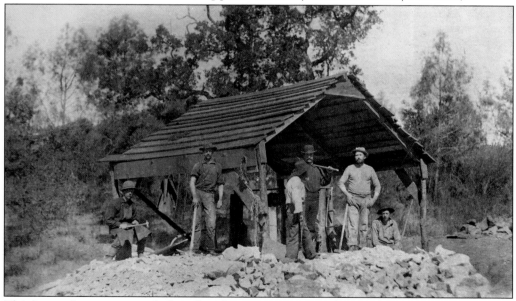

This "coyote" mine is typical of small-scale operations in Northern Calaveras. Ed Zumwalt is on the extreme left and Tom Fahey the extreme right, both from Mokelumne Hill. The men are digging old Tertiary placer deposits buried by volcanic flows, dropping a shaft into the gravels and extracting the river material to run through a sluice box or other gravity separating device. (Courtesy Mokelumne Hill History Society.)

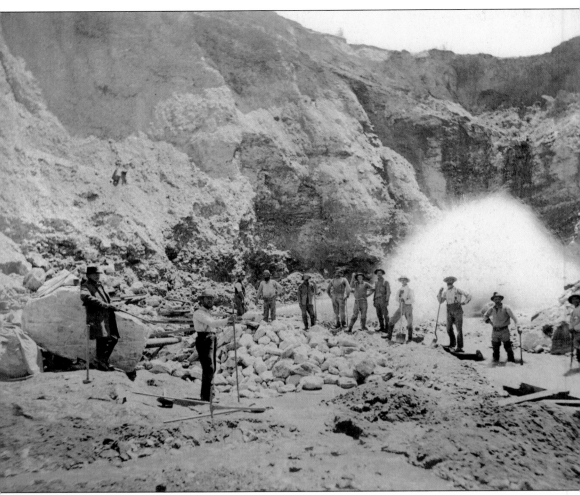

Members of the McSorley family of Chile Gulch were involved in mining activities beginning in the 1860s, both on their ranch and in Nevada, Mexico, Alaska, Siberia, Australia, and New Guinea. In 1876, Terrance McSorley and his partner Charles Lafayette Brown purchased a placer claim in Chile Gulch, naming it the Green Mountain for Brown's home state of Vermont. They soon hit pay dirt, and a stamp mill was erected to break up the conglomerates. It wasn't until the late 1890s, however, that the partnership of Tom and John McSorley and John Burton extensively hydraulicked the mine. A debris dam was constructed just west of present Highway 49, which was built over the tailings. By the start of World War I, hydraulic mining, long restricted for land and water conservation reasons, came to a halt. (Courtesy Mary Jane McSorley Garamendi.)

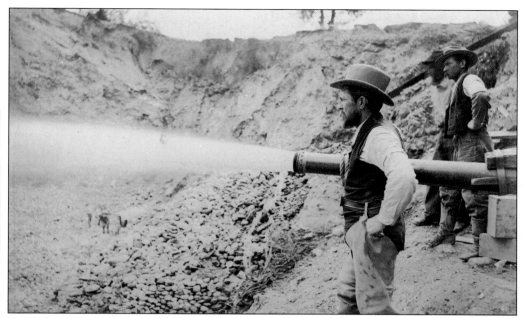

Water from the Mokelumne Hill Ditch was used to operate hydraulic monitors in the McSorley's Green Mountain mine. Held in reservoirs, the water was conveyed through a penstock to build head (pressure) and then to a canvas hose attached to a metal nozzle, as seen here. Gold was collected in extensive sluice systems utilizing constructed run-off channels. Here John Burton supervises the operations. (Courtesy Mary Jane McSorley Garamendi.)

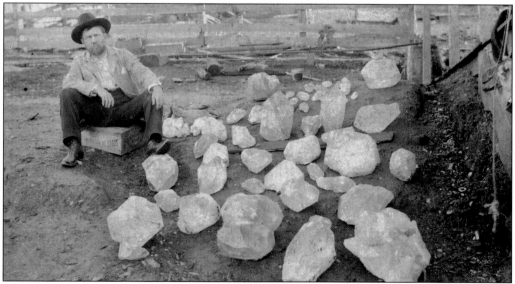

In 1896, Wisconsin entrepreneur John Burton began a partnership with the McSorleys to extract the enormous quartz crystals from their Green Mountain mine and sell them to Tiffany Jewelers in New York. Twelve tons were eventually shipped and used for lenses, jewelry, crystal spheres, and other items. The largest, weighing 2,200 pounds, was mined in 1906, and an enormous, polished crystal sphere resides in the collections of the Smithsonian Institution. (Courtesy Mary Jane McSorley Garamendi.)

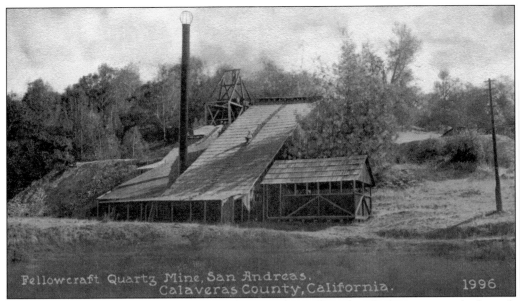

Fellowcraft Quartz Mine, San Andreas, Calaveras County, California. 1996

The Fellowcraft mine in San Andreas was discovered in 1852 and worked intermittently through the 1880s. The mine was again active by 1900 when this photograph was taken and closed finally in 1907. For this last phase, ore was crushed in a 10-stamp mill with the resulting pulp processed through Frue vanners and a Wilfley table to extract and concentrate the gold. The mill building displays a typical hillside mill configuration, where ore processing is based on a gravity-feed system. (Courtesy Calaveras County Archives.)

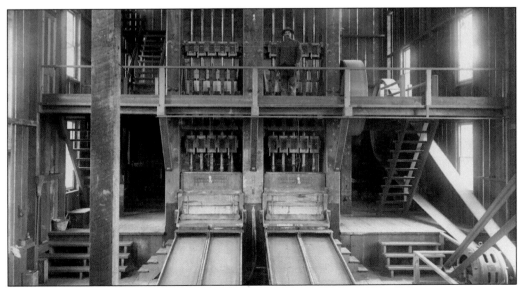

About two miles northwest of San Andreas, the Kate Hageman mine, originally known as the Comet, was active during the 1870s and 1880s when large amounts of ore were mined in an open cut and crushed in a stamp mill. Throughout the Mother Lode, after much experimentation in milling, the most efficient array of stamps was determined to be two batteries of five stamps (seen here), and therefore most mills contain multiples of 10 stamps. (Courtesy Calaveras County Archives.)

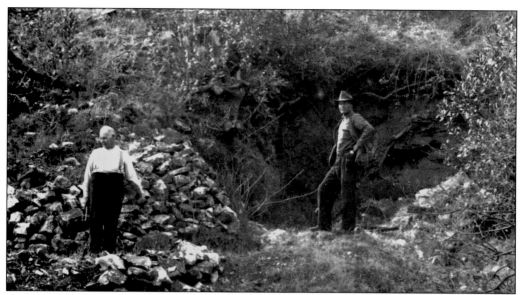

Two owners of a mine near Esmeralda pose at their adit around 1900. Virtually all small-scale miners in Northern Calaveras dabbled in the profession and were also employed as ranchers, shop keepers, laborers, drovers, and other paying occupations. The world of mining is populated by optimists, few of whom see their dreams realized. (Courtesy Wally Motloch.)

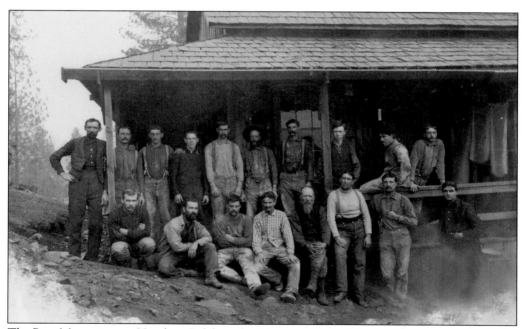

The Poor Man mine, up Humbug Gulch in the Glencoe Mining District, was active in the 1870s, 1890s, and in the early 1900s. The mine and boardinghouse were operated by the Lewis brothers, who at one time also owned the adjoining Wolverine mine. Ore was treated in a five-stamp mill in the early 1900s. Chester Arthur Danielson is third from left on the bottom row, boarding with Arvilla Lewis. (Courtesy Don Ames.)

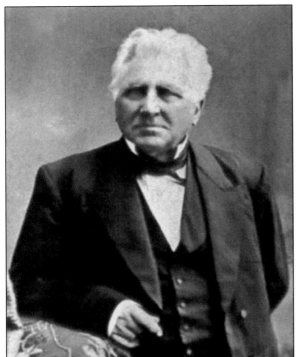

Located in Lower Rich Gulch, the Gwin mine was one of the most productive Mother Lode gold mines in the state in the 1870s. Initially known as the Paloma in the 1850s, the mine soon attracted the attention of the prominent Californian, Sen. William M. Gwin, who acquired the property in 1867 and operated it through 1882. The main shaft was extended to 1,530 feet, tapping an 80-foot wide vein. The mine was operated as a family venture, and the members resided in a luxurious mansion on the steep adjacent hillside. (Courtesy Calaveras County Historical Society.)

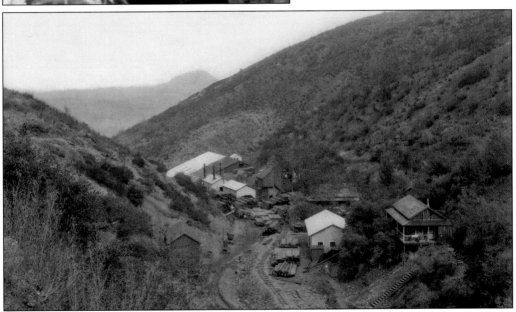

In 1894, the newly organized Gwin Mine Development Company purchased the old Gwin mine property and reopened the workings. They erected a 40-stamp mill—later increased to 100 stamps—a water-powered hoisting plant, and shops. A new vertical main shaft was sunk and the mine operated continuously until 1908, yielding $4,044,000 in gold. This view, taken about 1900 looking down Gwin Mine Road near Paloma, shows the surface plant and mill building. (Courtesy Calaveras County Historical Society.)

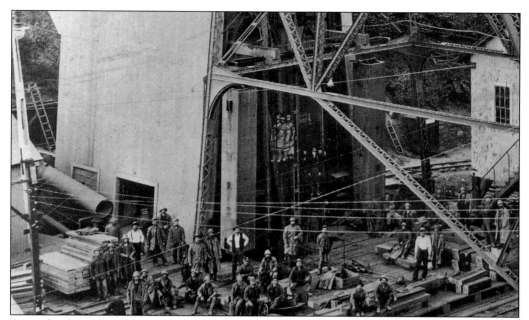

Power for the mill and hoist at the Gwin mine was supplied by Pelton wheels propelled by high-head water from the Mokelumne Ditch. The wheels turned the two great reels, wound in opposite directions and revolving as one, which raised and lowered tandem skips. Gwin mine workers are standing on a skip in the background, and ore skips are located on each side of the shaft. (Courtesy Calaveras County Historical Society.)

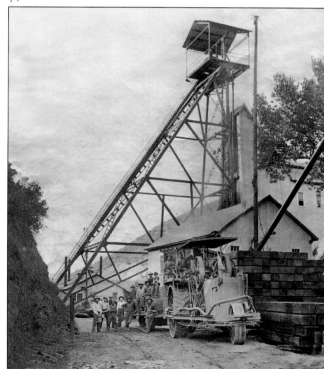

Early in the 1900s, a large, well-engineered steel head frame replaced the older one of wood timbers. This head frame, dismantled along with the surface plant in 1918, was shipped to Tonopah, Nevada, for further use. (Courtesy Calaveras County Archives.)

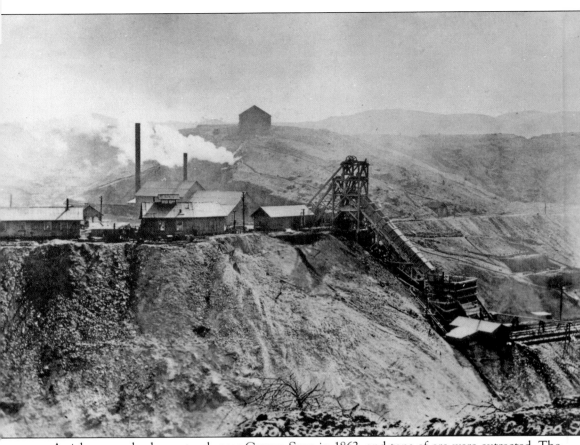

A rich copper lead was struck near Campo Seco in 1862, and tons of ore were extracted. The boom ended with the close of the Civil War, however, and the mine languished until reopened by the Penn Mining Company in the late 1880s. The mine was again rejuvenated in 1898, and the following year the company built a smelter, sunk two deep shafts, constructed a tram between the two, and equipped the mine with a crushing and grinding plant, eight roasting furnaces, and a blast furnace. During its heyday, the Penn mine was the most important copper mine on the West Belt of the Mother Lode. Gross returns from its operations in the period 1899–1919, including gold and silver, were valued at $7,362,562. The last hurrah for the mine occurred during World War II, when it reopened to meet the wartime demand for copper and operated from 1943 to 1946. (Courtesy Calaveras County Archives.)

Largely abandoned after the Gold Rush, Campo Seco was rejuvenated during the Penn Mine's 20-year period of productivity. The town's resurgence lasted until the mine's closure in 1919 in response to the post–World War I economic slump. (Courtesy Calaveras County Archives.)

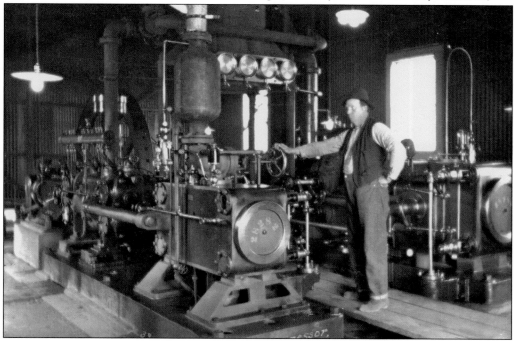

Thomas Cook Jr., son of the Irish Cook family who settled in the Burson-Chile Camp area in the late 1850s, became an engineer for the Penn Copper Company. He is seen in this 1910s photograph with the large compressor that provided power to the mine and mill. The Cook home is now the East Bay Municipal Utility District (EBMUD) ranger station on Camanche Parkway. (Courtesy Calaveras County Archives.)

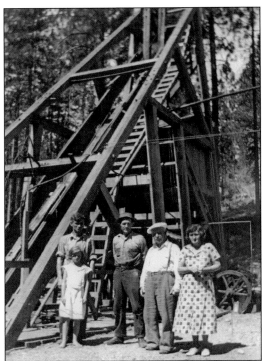

Located near Rail Road Flat, the Sanderson mine was originally worked sometime prior to 1869, and again extensively in 1875. After lying idle for many years, it was reopened in 1933 by George Buyck (center) and Charlie and Marjorie Tynon (right); on the left are George and Mildred Moody. The mine ceased operations in 1938. (Courtesy Don Ames.)

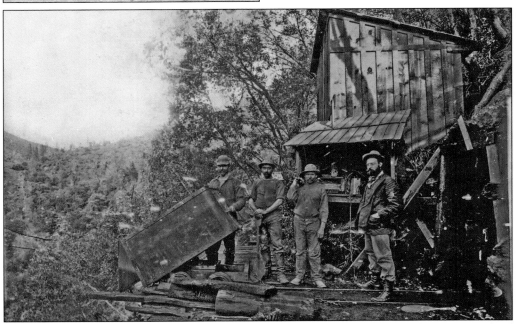

At another small mining venture, this group of miners poses as they dump their ore car's load onto the waste rock pile at their mine. Underground, "country rock" removed to expose ore deposits is sent out in railed cars and added to the growing mound in front of the adit. Pay dirt (ore) was stockpiled separately and then removed to the mill or separation facility. (Courtesy Calaveras County Archives.)

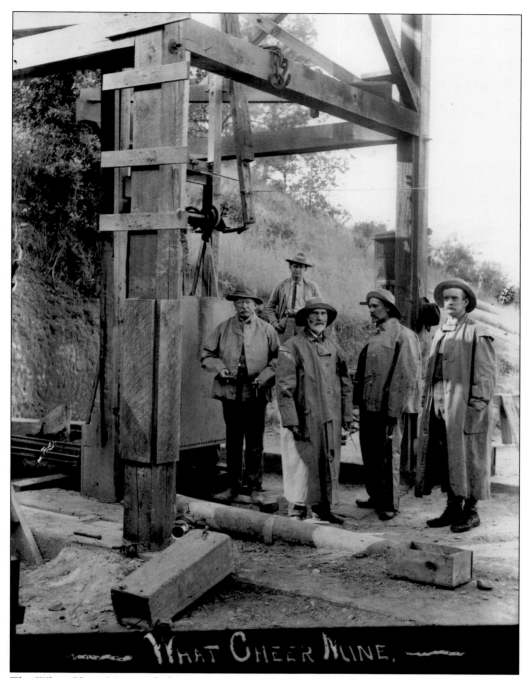

WHAT CHEER MINE,

The What Cheer Mine, a drift mine located on the Deep Blue Lead near Mokelumne Hill, was active prior to 1871. In that year, an inclined adit and several drifts and crosscuts were driven, but it wasn't until 1887 that a five-stamp mill was erected. Shortly thereafter, the mine was closed and remained idle except for some activity in 1899–1902 and development work in 1935–1937. This photograph was taken by Mokelumne Hill photographer Edith Irvine in about 1900. (Courtesy Brigham Young University.)

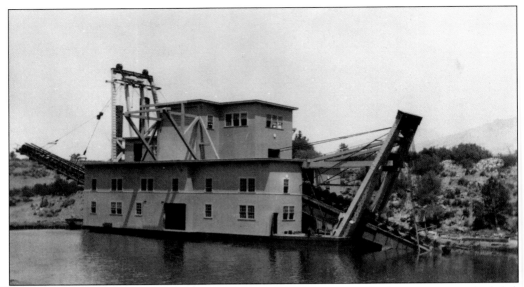

By 1900, placer gold was being recovered from river bottoms using dredges, a process which left distinctive mounds of cobbles across the landscape. Dredges began operating in Jenny Lind in 1904 and around Camanche on the Mokelumne River in the early 1910s, with operations continuing through the 1930s. During the Depression years, smaller operations utilized drag-lines, "doodle-bugs," and suction dredges. In 1927, the bucket-line "Lancha Plana No. 1" dredge started digging up the old town for which it was named. (Courtesy Calaveras County Archives.)

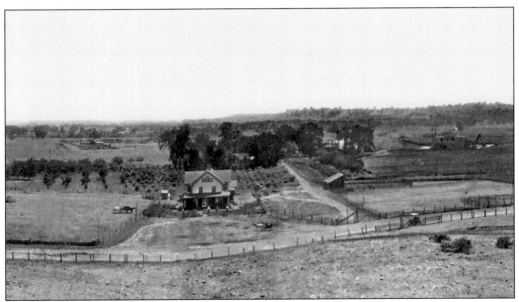

The vast fields of gold dredge tailings along the rivers and streams attest to the sheer magnitude of the work the dredgers did. The first Calaveras bucket-line dredge was built by the Calaveras Gold Dredging Company at Jenny Lind. By 1909, the Dennis home and ranch seen in this photograph sat like an island in the middle of tailings being worked by the Calaveras Dredge and the Isabel No. 1. (Courtesy Calaveras County Archives.)

Three

THE WORLD RUSHED IN

From the time of the first discovery of gold in this country, men speaking different languages, accustomed to different habits, educated in different schools, brought up under different governments, and controlled by different prejudices, flocked to the land of gold.

—*San Andreas Register,* September 15, 1866

The California Gold Rush is identified as the greatest worldwide migration in peacetime history. Within a few years, hundreds of thousands of hopeful miners and entrepreneurs poured into the Sierra Nevada foothills and then spread out across the landscape. Although most returned to their homelands, many stayed to make new lives in this land of opportunity.

Calaveras County, in the Southern Mines, is distinguished by a drier and hotter climate, less reliable water, and more complex gold deposits than in the Northern Mines. It also has a more ethnically diverse population. This international society fed itself by attracting newcomers, and Calaveras swarmed with representatives from around the globe. The first to arrive in 1848 were the Californios and Mexicans, followed by those from the Pacific Rim as reports of gold spread via sailing ships. Following on their heels were the forty-niners from the eastern states and from Europe who had jumped aboard ships and launched overland treks in 1848, bound for California. This initial rush lasted for about a decade before the easy gold was exhausted and the dream of instant wealth dissolved. People kept coming, however, with later migrations from southern Europe adding more flavor to the Mother Lode stew.

Chileans and Mexicans arrived with considerable mining skills. The Chinese—a legendary group of hardworking miners, railroad builders, cooks, and ditchdiggers—made up 22 percent of the county population in 1860. The majority of inhabitants were Anglo American, with subgroups of English, Irish, Welsh, and Scots, as well as American Yankees, Southerners, and "Pikers" from Missouri. Blacks, both slave and free, came to try their luck. Europeans in early Calaveras County included Germans, Jews, Swiss, French, Basque, Italians, and Eastern Europeans as well as miners from New Zealand and Australia.

In towns and mining camps, these groups tended to gather with fellow nationals. Discrimination drove some apart, while others settled together for the camaraderie of familiar language and customs. Towns teemed with restaurants, lodging houses, and bars catering to particular nationalities, and a babble of languages filled the streets. Some of these groups left descendants who remain today, and some left names on the landscape such as Chile Camp, Italian Gardens, China Gulch, Negro Hill, and French Hill.

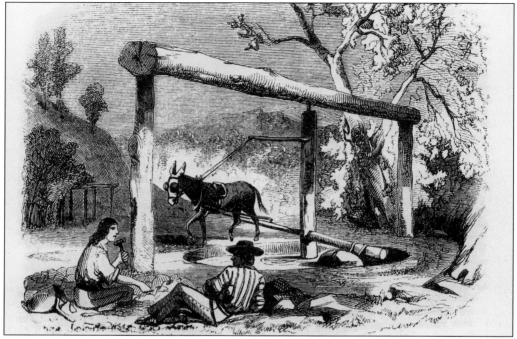

Mexicans, often with families, arrived in 1848 from Sonora and other northern provinces with practiced mining skills. Among the techniques they introduced was the *arrastra*, a simple but effective method for crushing ore. The lode-bearing rock was ground between the drag stones—pivoted around a central post—and the tightly fitted mortar stones lining the bottom of the circular enclosure, liberating the precious gold ore.

Many of the earliest buildings in the county were constructed by Mexicans of adobe bricks. Most of them, however, have disappeared. One important Mexican community lived along the banks of Calaveritas Creek and featured adobe stores, fandango halls, hotels, and residences. This home of a Mexican midwife in Calaveritas, who delivered generations of local children, is a rare survivor. (Courtesy Wally Motloch.)

Several locations in the county were notable as early Chilean settlements, including Chile Camp, Chile Junction, and Chile Gulch, near Mokelumne Hill where the Chilean War was fought in 1849. This dispute was between Chileans, who had arrived in California in large numbers in 1848 and 1849, and Americans who coveted their rich claims. The story of Yankee prejudices and vigilante justice is a sad reminder of those ruthless days. The home of Chileans Tiburcio and Josefa Aros (below) stood for many years at Chile Camp near Campo Seco. Arriving with one young son, the family mined and added six more children to the community. Their youngest son, Celistino, born in 1877, posed in front of Josefa's bread oven beside the house. (Right courtesy Calaveras County Archives; below courtesy Calaveras County Historical Society.)

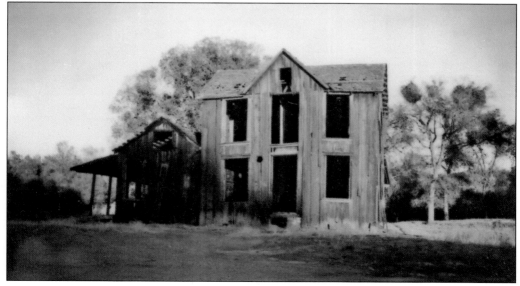

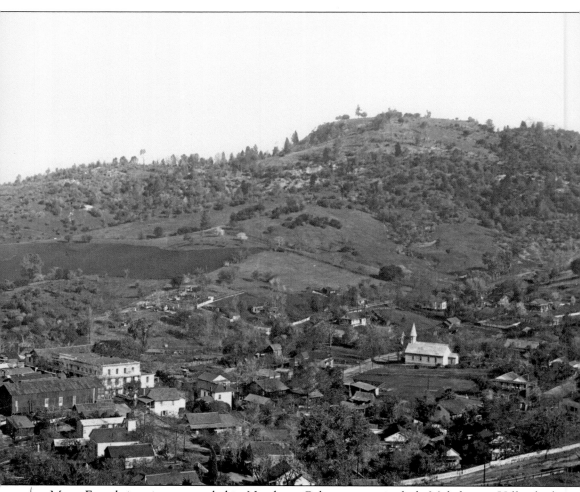

Many French immigrants settled in Northern Calaveras, particularly Mokelumne Hill, which had one of the largest populations in California outside of San Francisco. The community—once concentrated along modern Lafayette Street—featured bakeries, restaurants, schools, a hospital, and a fraternal society. Les Fourcades, a mining camp on French Hill, on the eastern edge of town, was the site of the French War, which erupted when some Americans attempted to move onto rich diggings discovered by a group of French nationals. The French built stone breastworks, raised the Tri-Color, and stood off the invaders. The dispute was finally mediated when the French consul arrived from San Francisco, but not before several men were wounded and one killed. In this photograph, taken in the early 1900s, French Hill rises in the background, and the Catholic church on Lafayette can be seen below. (Courtesy Mokelumne Hill History Society.)

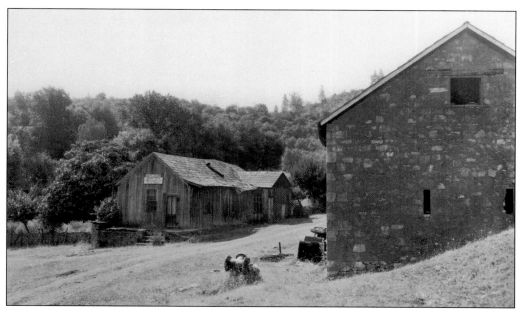

The earliest European settlement in Calaveras County is in Happy Valley, where French fur trappers are said to have had a camp in the 1830s or 1840s. After 1848, French miners expanded the community and Louis and Eugene Boudin raised grapes and constructed a stone winery. Lying just east of Mokelumne Hill, Happy Valley was later mined for its placer deposits, and the winery (on the right in the photograph) was used by the North Star Mine as an office. (Courtesy Calaveras County Archives.)

The only structure remaining from the French community in Happy Valley is an adobe residence consisting originally of two rooms and a loft. Said to have been constructed prior to the Gold Rush, it would be the oldest extant building in Calaveras County. (Courtesy Calaveras County Archives.)

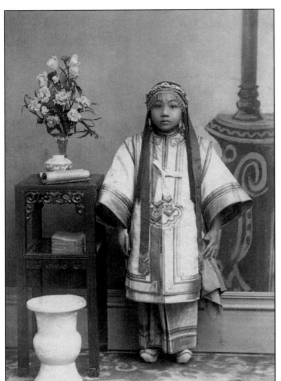

West Point had a large Chinese settlement by 1870, occupying two streets and consisting of about a dozen wooden buildings. Ah Cow and Lun Kee operated stores and other buildings included a "Joss House" (temple), gambling houses, restaurants, and lodgings. China Mary, photographed here as a young girl, was one of the few women in Chinatown. She later moved to San Francisco where she was visited by women friends from West Point. (Courtesy K. Smith, T. A. Wilson album.)

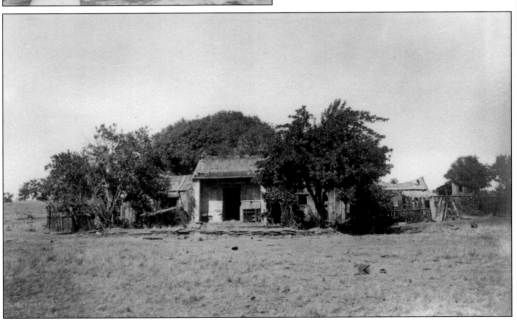

By 1857, a Chinatown was thriving in San Andreas at the intersection of St. Charles Street (Highway 49) and Court Street. As late as the 1860s and 1870s, the Chinese in San Andreas constituted nearly half of the town's population. Their temple (or Joss House, shown here) was located on the present site of Calaveras High School. (Courtesy Calaveras County Archives.)

Chinatown in Mokelumne Hill was located on East Center Street, extending from Main to the Catholic cemetery, and south down the street now named China Gulch. One of the largest in the Mother Lode, it served a widespread community of miners who came for food goods imported from China, fellowship, gambling, and to visit one of the two temples in town. (Courtesy Calaveras County Archives.)

Most Chinese returned home after years of working in California, many because of increasing bigotry and discrimination, and others to retire with their families on their often substantial earnings in "Gum San" ("Golden Mountain," the Chinese name for California). Some Chinese, however, remained as part of the local community, as did this worker on the McSorley's Green Mountain mine. (Courtesy Mary Jane McSorley Garamendi.)

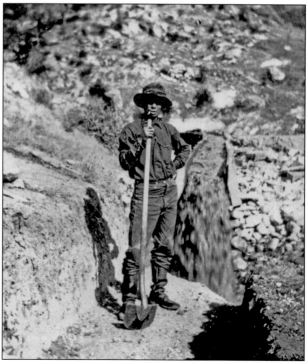

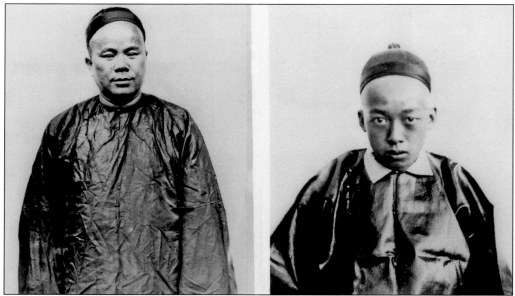

Chinese merchants frequently came to California with their wives and children, and increased their families while they were here. Although the names of this father and his children are not known, it is likely that he ran a store in Mokelumne Hill in the 1880s. The mother (not pictured) would have helped in the store, along with the children when old enough, and the family likely lived in an upstairs apartment. The stores stocked homeland foods such as dried fish, preserved vegetables, peanut oil, rice, dried seaweed, soy sauce, bean paste, rice wine, ginger, and ginseng. Dry goods included everything from shoes to firecrackers, and daily lottery tickets were sold to Chinese and non-Chinese alike. Stores often had a pharmacy section where an extensive array of traditional herbs and elements were compounded for cures. These portraits of Mokelumne Hill Chinese were taken by local photographer Frank Peek in about 1900. Frank had a photography studio in town and captured many local scenes and personages. (Photographs by Frank Peek; courtesy Mokelumne Hill History Society.)

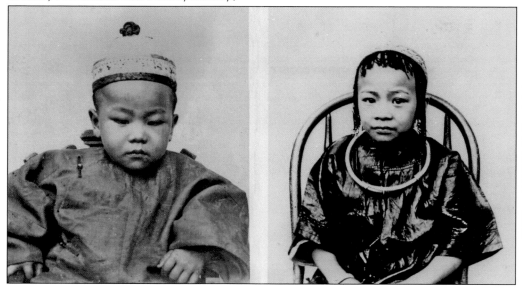

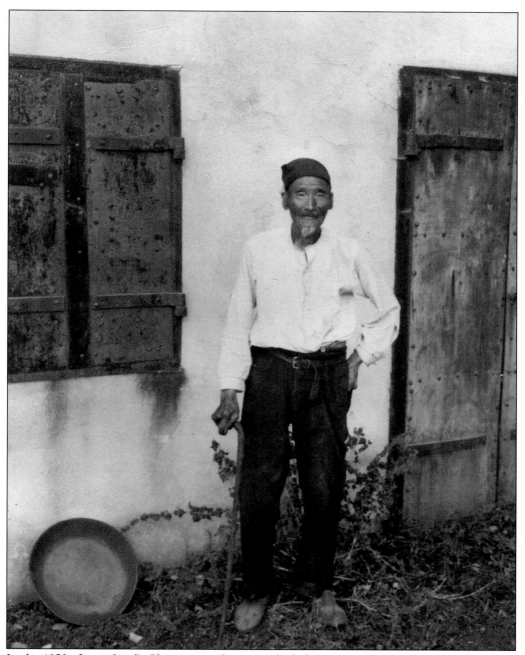

In the 1850s, Jenny Lind's Chinese population worked placer mines on the Calaveras River and built a Chinatown said to be "one-half mile long." Ah Lin was one of the last Chinese residents, an active miner and a familiar figure in town. He often worked at the Gregory Ranch, giving out fresh Chinese candy to the American children and offering condolences to women who had only girls. (Courtesy Calaveras County Archives.)

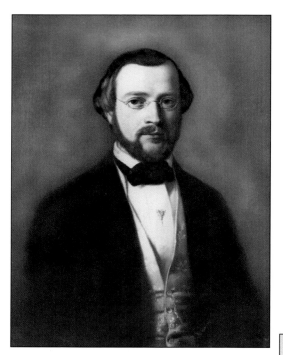

Embroiled in political upheaval in Germany, many Germans took advantage of opportunities provided by the Gold Rush and settled in Calaveras. In addition to mining, they established breweries in almost every community, operated businesses, and farmed. One of the most successful was Charles Grunsky, who opened a store at Pleasant Springs in 1849, and operated a wholesale house in Stockton, running a team of mules to supply camp stores along the Mokelumne River. (Courtesy Bancroft Library.)

Immigrant Jews arrived early in Calaveras gold camps, coming principally from Bavaria, Prussia, Russia, Germany, and Bohemia. Successful tradesmen, they dispensed dry goods and wares from all over the world, and grubstaked miners and businessmen. Henry Wolfstein ran a successful cigar store in San Andreas for many years. (Courtesy Calaveras County Archives.)

During the famine years (1846–1851), over half the population of Ireland starved or emigrated; many of them followed "the Irish Dream" to California like the two men shown here. Here they didn't have to endure the harassment and insults experienced by their countrymen on the Eastern Seaboard. They set out for the gold fields, building cabins in the hills, finding a "poke," and gathering around log fires in the evenings to sing the songs of their native land. (Courtesy Calaveras County Historical Society.)

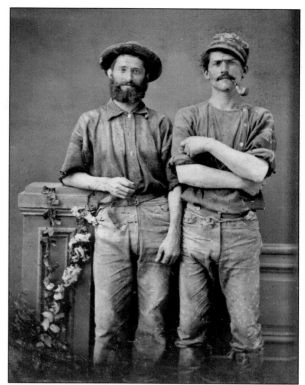

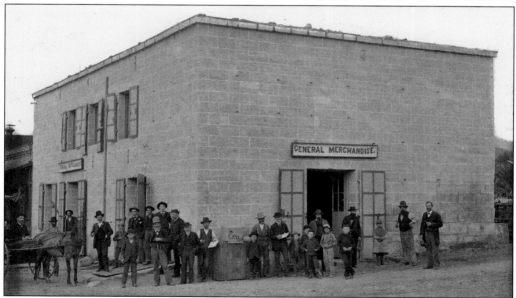

In 1853, Irishman Thomas Corcoran erected his stone store, with no architectural embellishment, on the corner of St. Charles (Highway 49) and Main Streets in San Andreas, one of three stone buildings constructed that year. Later operated by Corcoran and Sullivan, then as Sullivan and Gallagher, it had a long connection with the string of Irish store and saloonkeepers in Calaveras. (Courtesy Calaveras County Archives.)

James Ham, who emigrated from England in 1870, was one of many of his countrymen who settled in Calaveras to mine ores, marry, and establish families. As Ham is a common name in Cornwall, it is assumed that he was well acquainted with hard-rock mining, albeit in the tin mines of his native land. Many Cornishmen came to California as experienced miners, millmen, and mine operators. (Courtesy Wally Motloch.)

Although some black pioneers arrived as free men, others came as slaves with their owners. Edmington Binum, who came to Calaveras in 1856 from Mississippi, labored on the Cloyd and Norman ranch near Yaqui Camp. Eventually buying his freedom for $1,400, Binum sent for his wife, Margaret, and his family. Margaret became a beloved midwife and nurse, while son Lev operated the popular Bon Ton Chop House in San Andreas. (Courtesy Calaveras County Historical Society.)

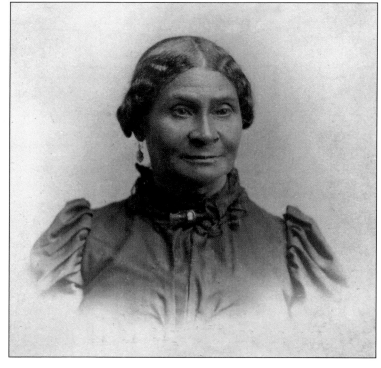

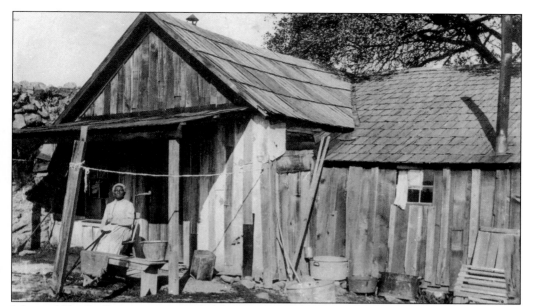

John and Phoebe Ferguson came to California as freed slaves, residing in Illinois by the early 1840s when their first son was born. The family came to California in the 1850s, where they lived first in Columbia, then moved to San Andreas by 1870. John operated a blacksmith shop at the fork of Mountain Ranch and Calaveritas roads, while Phoebe (Eliza), above, was a washerwoman. (Courtesy Calaveras County Archives.)

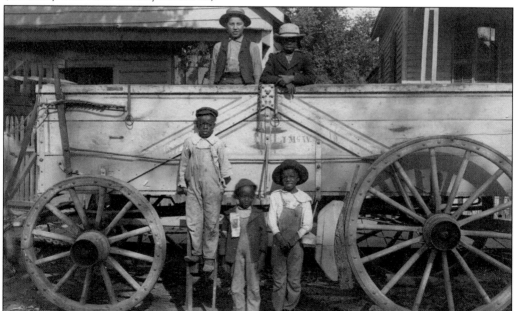

In the first decade of the Gold Rush, over 5,000 blacks came to California, many as slaves from the South, whose owners intended to work them in the gold fields. "Miner's Law," however, mandated that every man work his own claim, and in 1850 California entered the Union as a Free State. Experiencing prejudice in the cities, in the gold country African Americans used their success in the mines to overturn some of the worst intolerances. (Courtesy Calaveras County Archives.)

Beginning with the Gold Rush, "chain migration" (relatives and neighbors following earlier immigrants to a particular location) brought unprecedented numbers of Italians from near Genoa to the Southern Mines. In 1870, fully one quarter of all of the Italians in California lived in these counties. In Calaveras County, the names of these Italians appear in early documents, on streets and buildings, and among their numerous descendants who still reside here. The Italian immigrant community in Mokelumne Hill supported both an Upper and Lower Italian Gardens, business ventures owned in shares by several owners that served as springboards to new immigrants, giving them work and lodging while they saved money to establish themselves and a family. Columbus Day, October 12, was celebrated annually by the gregarious Italian community in Mokelumne Hill. Other events included the fall grape harvest and crush, sausage-making at Christmas time, and bocce ball playing. Loyal Catholics, the Italians and Irish attended the same churches and the many marriages between these two groups reflect this shared social and religious arena. (Courtesy Calaveras County Archives.)

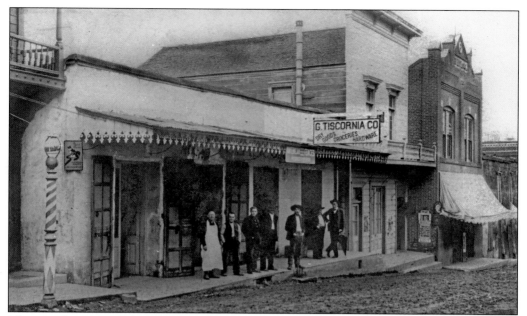

Many storekeepers in Calaveras were Italian, including the Domenghini, Raggio, Rodesino, and Dughi families of Mountain Ranch; the Cuneos of San Antonio Camp; Costas of Calaveritas; Cavagnaros of Camanche; Valentes of Indian Creek; and Rapettos and Carravias in Mokelumne Hill. In San Andreas, the brick store of J. A. Agostini no longer exists, but the stone store of Gerolamo Tiscornia is now part of the Black Bart Inn. (Courtesy Calaveras County Historical Society.)

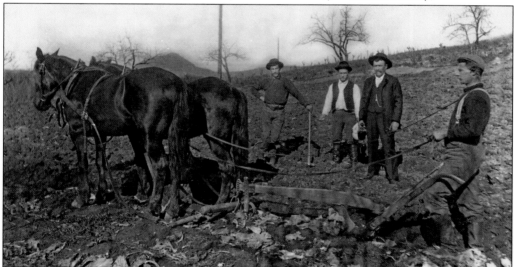

This photograph was taken at Mokelumne Hill's Upper Italian Gardens, at the present location of Marredda Gardens on Lafayette Street. Watching the plowing are (from left to right) John Queirolo, John Solari, and Andrea Lagomarsino. Upper and Lower Italian Gardens (on West Center) supplied vegetables and fruits—including oranges, apricots, lemons, almonds, cherries, peaches, and grapes—by wagon not only to the town but to mines, hotels, boardinghouses, and homes as far away as Sutter Creek, Paloma, West Point, San Andreas, and Middle Bar. (Courtesy Mokelumne Hill History Society.)

Stephen Valente, like many of his countrymen, came to Calaveras in the 1850s. First working as a miner at San Antonio Camp, he resided near Angelo and Angela Canevaro, also natives of Italy. In 1876, after the death of her husband, Angela married Stephen Valente, and the couple operated a store in Esmeralda before moving to their final destination on Indian Creek, near the Calaveras Mine (pictured), where Stephen farmed and operated a stage stop. (Courtesy Calaveras County Archives.)

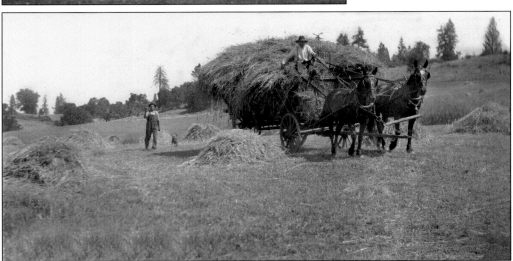

Carlos Fillipini came to Calaveras from Switzerland in 1855, establishing his home ranch near El Dorado. He was one of the early stockraisers to utilize the high country as summer range for his cattle and hogs. He built a cabin, milk house, and corrals, manufacturing butter and cheese at his range headquarters at present Sky High Ranch, returning in the fall to cut hay and pasture his stock on the home farm. (Courtesy Wally Motloch.)

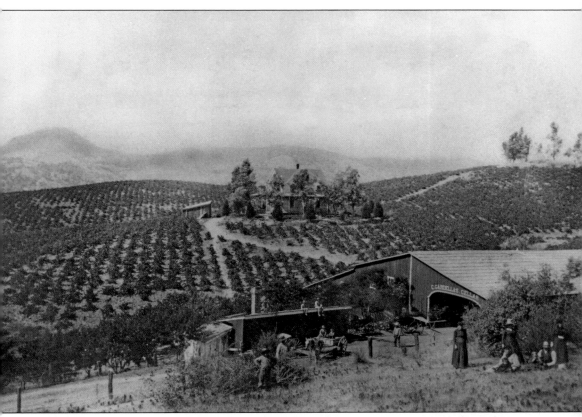

Commercial winemaking in Calaveras began in 1851, with 1,000 vines set out on the Calaveras River. Mokelumne Hill was another center of wine production, with the vineyards of Madame Catia and Frances Mercier at Chile Gulch, and Frederick Mayer and Catherine Lefoy on West Center Street. By the 1880s, Charles Gardella had purchased the Lefoy acreage and was operating a stage station, bar and hotel, wine cellar, and vineyard. The stone walls of the winery are still extant next to the road, and its barred windows have inspired locals to call it "the Jail." (Courtesy Calaveras County Archives.)

John and Victoria Ratto and their son Paul emigrated from Italy in 1881 and established a ranch along Calaveritas Road. This stone bread-baking oven that they constructed contains good luck talismans of a perfume bottle and man's button mortared into each side of the doorway. The oven has been moved to the rear yard of the Calaveras County Museum where it is fired up for special events. (Photograph by Julia Costello.)

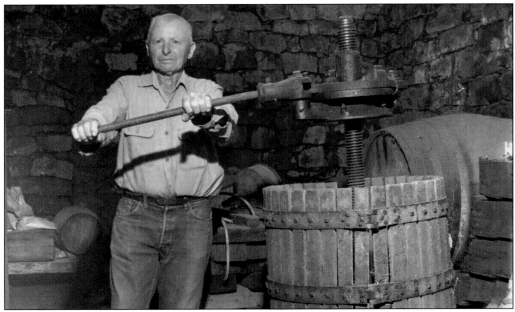

Charlie Lavezzo, born near Pine Grove in 1891, moved with his parents to Lower Italian Gardens in Mokelumne Hill. At 21, he purchased his first share in the gardens, and in 1939, bought out his last partner, Henry Sanguinetti. The old wine press was last used in 1957, although the wine cellar still stands next to Charlie and Wynema's old home. (Courtesy Mokelumne Hill History Society.)

Four

✹ MOKELUMNE
ON THE HILL✹

With the discovery of gold in Coloma in January 1848, the rush to the Mokelumne River was soon underway. Riches along the watercourse were concentrated at Big Bar (present Highway 49 crossing), Middle Bar, and on "The Hill." Here a permanent settlement grew around tent stores and bars, with stone buildings being erected by the early 1850s. A devastating fire in 1854 prompted more construction in rhyolite, the distinctive volcanic stone quarried nearby.

The largest town in Calaveras County, Mokelumne Hill served as the county seat from 1852 to 1866. The cosmopolitan population contained large numbers of French, Germans, Chinese, and Italians, along with immigrants from the Eastern states. Water arrived by canal, while stages connected the town to Stockton where ships completed the link to San Francisco.

With the decline of free placer gold by the 1860s, the town declined, subsisting on an agricultural economy. Hard-rock mining boosted incomes around 1900 and helped the region weather the Great Depression of the 1930s. Mokelumne Hill's historic charm and small-town character is preserved by its location, surrounded by active family cattle ranches that stave off development.

Today Main Street and Center Street still display many of the commercial buildings from the town's mining days, while historic homes are scattered along winding paths turned into streets. The water no longer arrives via an open ditch, the reservoir has been turned into the town ballpark, and mining no longer runs the economy. However, the northern horizon is still dominated by Butte Mountain, the Mokelumne River runs cool and clear, and the surrounding landscape is preserved in open fields and stands of oaks by family cattle ranches.

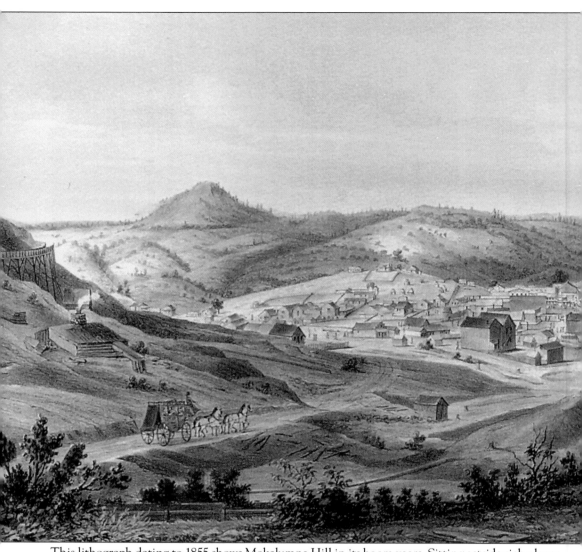

This lithograph dating to 1855 shows Mokelumne Hill in its boom years. Sitting astride rich placer deposits and surrounded by mining camps, it served as the economic and social center of the region. At this time, Calaveras included what is now Amador, and Mokelumne Hill was centrally located to serve its constituency. In the left foreground, a stagecoach is descending Stockton Hill from that western valley town, while Butte Mountain defines the northern skyline. Coming in from the east, and prominent in the foreground, is the Mokelumne Hill Canal. Completed in 1852, it was the most important economic boon to Northern Calaveras, opening up mining and development opportunities from Glencoe to Camanche. The town boomed with the success of the surrounding mines. In addition to the productive mining at Big Bar and Middle Bar, the town itself was situated astride several rich Tertiary river channels and diggings covered the bordering hills. Miner J. D. Borthwick describes the town in 1851: "It lies in a sort of semicircular amphitheatre of about a mile in diameter, surrounded by a chain of small eminences, in which gold was found

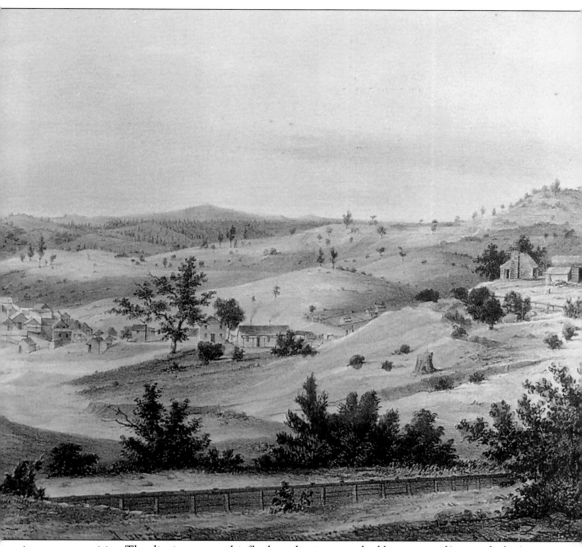

in great quantities. The diggings were chiefly deep diggings, worked by means of 'coyote holes,' a hundred feet deep, and all the ground round the town was accordingly covered with windlasses and heaps of dirt. . . . The population was a mixture of equal proportions of French, Mexicans, and Americans, with a few stray Chinamen, Chileans, and suchlike. The town itself, with the exception of two or three wooden stores and gambling saloons, was all of canvass." The town quickly matured. In addition to the courts, jail, and government offices, Mokelumne Hill was one of the first towns in the county to receive a post office. It also boasted a remarkable number of bars, was notorious for fights and murders, and reveled in horrific bull and bear fights. Civilization arrived with the women, however, and churches, hospitals, and a school were soon established. Thriving communities of French, German, Italians, Chinese, and Jews provided diverse cuisine and gave the town a cosmopolitan air. By 1872, the *Calaveras Chronicle* reported a circulation of 16,000. (Courtesy Bancroft Library.)

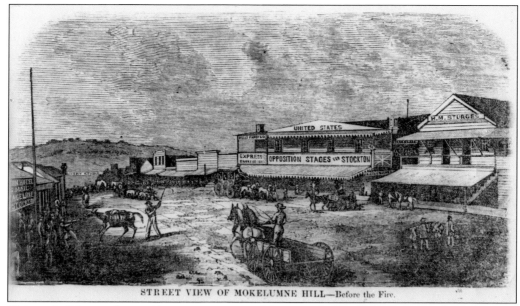

STREET VIEW OF MOKELUMNE HILL—Before the Fire.

This early lithograph provides a rare picture of the town before 1854 when the first of several major fires occurred. At this time, the community largely consisted of wooden buildings and tent structures, but boasted the names of businesses—such as Sturges'—that survived the fire and continued to play a prominent role in the history of Mokelumne Hill. (Courtesy Mokelumne Hill History Society.)

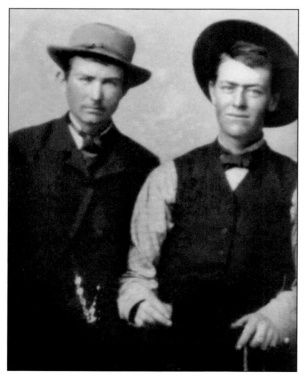

Friends Hugh McSorley and James Nuner, photographred in 1884, were from pioneering families that were prominent in the developing town. (Courtesy Mokelumne Hill History Society.)

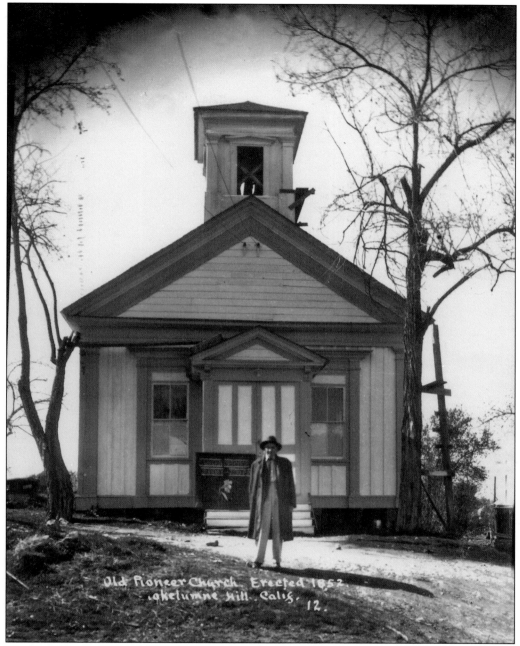

The First Congregational Church was organized in 1853, its original structure taken in the 1854 fire. It was rebuilt in 1856 by the congregation: local men volunteering after a long, hard day of mining while the ladies took up collections every Saturday night—likely outside of the local saloons. This church is reported to be the oldest Congregational church building in the state of California and continues to serve the spiritual needs of the local residents. (Courtesy Mokelumne Hill History Society.)

went to one & only one service in this
church w/ my best friend Jenni Felte.

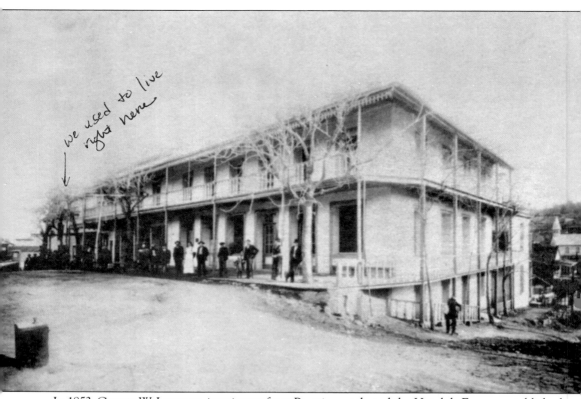

we used to live right here

In 1853, George W. Leger, an immigrant from Prussia, purchased the Hotel de France, established in 1851. This canvas and wooden structure was destroyed in the 1854 fire, replaced by a single-story building of brick and rhyolite with four French doors and four windows facing Main Street. The ballroom at the rear soon hosted socials and benefit gatherings, drawing participants from distant mining camps. By 1858, the hotel's name had been changed to Hotel d'Europe. After 1866, when the county seat moved to San Andreas, the adjacent two-story, stone building housing the courthouse and county government offices was purchased by George and W. P. Peek. In 1874, after Leger's hotel was once again destroyed by fire, Leger purchased the neighboring courthouse structure and included it as part of his new, two-story Hotel Leger. George Leger died in 1879, whereupon the hotel was operated by a succession of owners including George Muths, Kaufman Hexter, and Myron Greve. This photograph from about 1900 includes a glimpse of St. Thomas Aquinas Church down Lafayette Street. (Courtesy Mokelumne Hill History Society.)

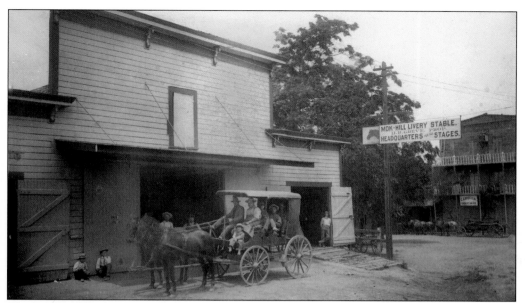

The livery stable was a vital establishment in every Gold Rush town. In addition to blacksmithing, liveries rented horses and buggies to town residents and stabled the horses of visitors. During the 1890s, Harry R. Greve's livery was located on the present site of the post office. (Courtesy Donald Greve.)

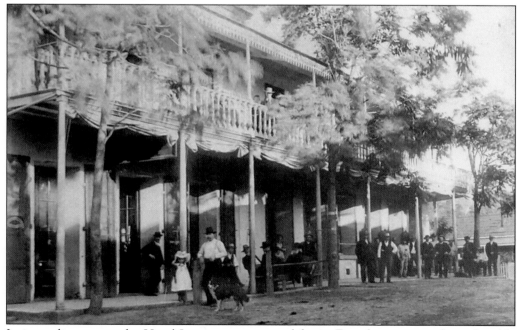

In its earliest years, the Hotel Leger was renowned for its French cuisine and comfortable accommodations. Formal invitations were issued for cotillions which drew participants from across Calaveras and Amador counties. This photograph shows the rolled-up screens, which could be lowered to provide afternoon shade and protection from billowing dust that rose every time a team drove past on the dirt street. (Courtesy Hotel Leger.)

The first public school was established in 1854 on the hill north of Church Street. In 1864, the left portion of the school was constructed, with the second room added by 1900. This school building was used until 1964 and is now a private residence. (Courtesy Mokelumne Hill History Society.)

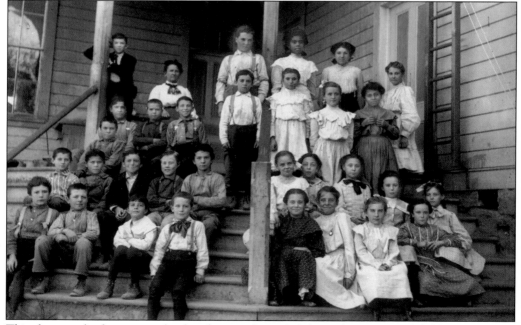

This photograph of grammar school students in about 1913 shows the presence of children from many ethnic backgrounds in town. Carl Dell'Orto, age 14, is in the center at the rear. The photograph was taken by local photographer Edith Irvine. (Courtesy Brigham Young University Library.)

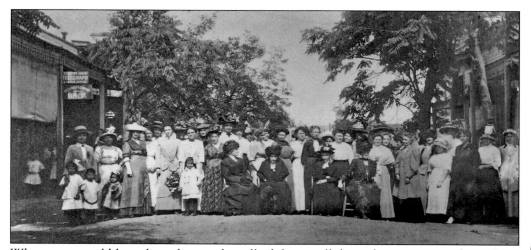

What event could have brought together all of these well-dressed townswomen for a photo opportunity on Main Street? Seated in the front row are four of the town matriarchs (from left to right): Emma Wells, Amanda C. Nuner, Anna Eliza Zumwalt, and an unidentified woman. (Courtesy Hotel Leger.)

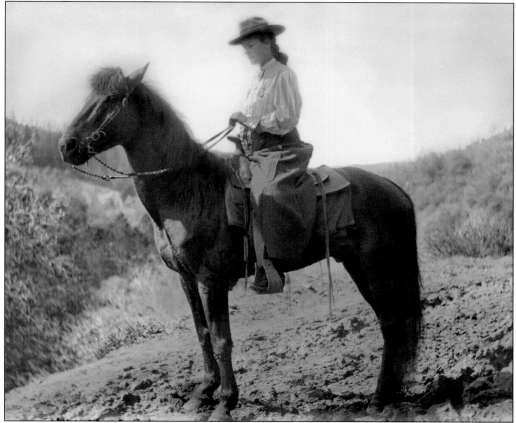

Jeanette Peek poses on her horse on the outskirts of town about 1900. (Photograph by Edith Irvine; courtesy Brigham Young University Library.)

Frank Bernardi constructed this building in the mid-1880s as a saloon and office building. It was later owned and operated for many years by Severino Gobbi. Now a private residence, the swinging saloon doors have been replaced, but the Italianate false front and elaborate gingerbread decorations still grace its facade. Joshua Albright is standing in the doorway. (Courtesy Mokelumne Hill History Society.)

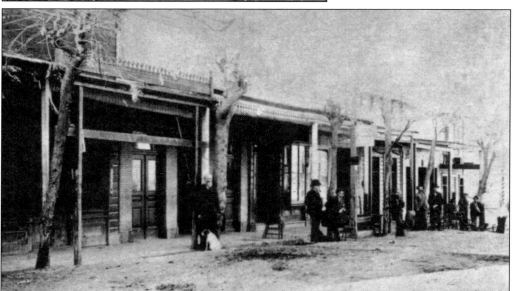

This view down the west side of Main Street—with shopkeepers and customers drawn to the photographer's camera—captures the heart of the business district. The modern streetscape looks much the same, as these stone buildings survived multiple fires. Each time, their owners reopened their dry goods, butcher shop, drug store, or tobacco and liquor businesses. (Courtesy Calaveras County Archives.)

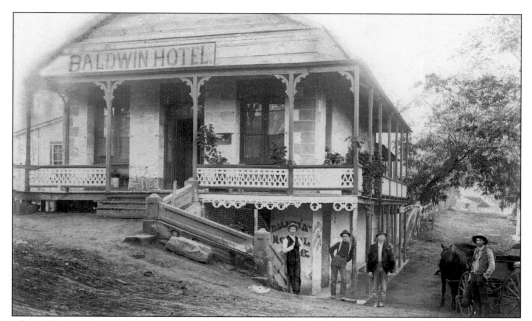

This 1854 stone building was originally a store owned by John Rogers and John Rappetto. In the late 1890s, it was remodeled with the addition of a veranda and gable-end gingerbread. Charles Gardella then established the Baldwin Hotel in the building, and some years later Gardella's Mortuary occupied space in the basement. In this photograph, Joe Gardella is leaning against the post and Steve Cuneo is beside the horse. (Courtesy Mokelumne Hill History Society.)

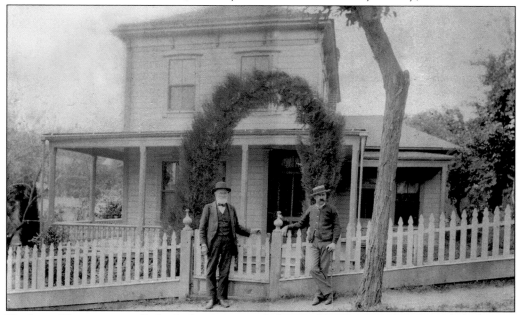

Kaufman Hexter reportedly built this two-story Italianate Victorian in 1889 as a gift for his son and daughter-in-law. The Hexter family owned and operated the Hotel Leger, located directly across Lafayette Street. The Schrag family resided in this lovely frame home for many years; Henry Schrag is on the right in this photograph. (Courtesy Mokelumne Hill History Society.)

A fresh, flowing spring on Lafayette Street led to the establishment of the first soda works in town, established in 1858 by Newman and Drake. In early 1874, the business was sold to Charles Werle and Joshua Albright, becoming the Pioneer Soda Factory. By 1876, it was producing 50,000 bottles of soda per month. This photograph of the C. A. Werle Soda Works and residence, taken in the late 1890s, is testimony to the success of this enterprise. (Courtesy Calaveras County Historical Society.)

In 1909, the Werle family moved to Oakland, selling the soda works to Herman and Dorothy Maasberg, who continued to provide soda, mineral water, and ice throughout the county. The advent of the automobile by World War I enabled them to market their product over a much wider area. After several additional changes of ownership, nearly 100 years of production ended in 1950. (Courtesy Mokelumne Hill History Society.)

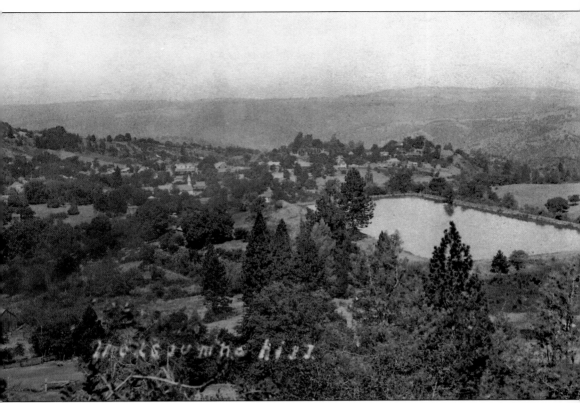

The need for an uninterrupted supply of water for mining, agricultural, and domestic use led to the establishment of the Mokelumne Hill Canal and Mining Company in November 1852. By 1854, a reservoir for the storage of water had been constructed on the saddle between French Hill and Sport Hill on the eastern edge of town. This view from above the reservoir overlooks the town site, with the steeple of St. Thomas Aquinas Church and the Hotel Leger visible. In 1973, the reservoir was abandoned and replaced by a water tank on Sport Hill. The reservoir was converted to Hobbs Field in the 1980s, with its southern and western walls leveled for the outfield. (Courtesy Mokelumne Hill History Society.)

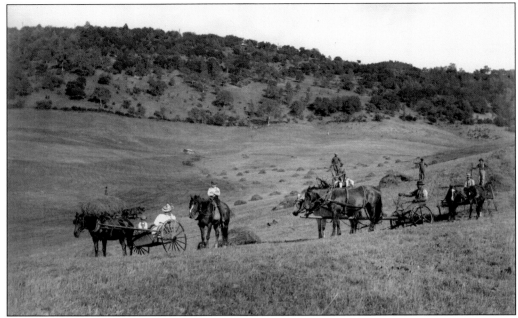

On the road to Middle Bar, west of Mokelumne Hill, the Dell'Orto family has ranched for over 100 years. Alice Prindle Dell'Orto and her son Lincoln are seated in the buggy, son Carl is on horseback, and Alice's husband, Joseph, is seated on the mower. Ranch hands complete this haying crew pictured *c.* 1905. (Photograph by Edith Irvine; courtesy Brigham Young University Library.)

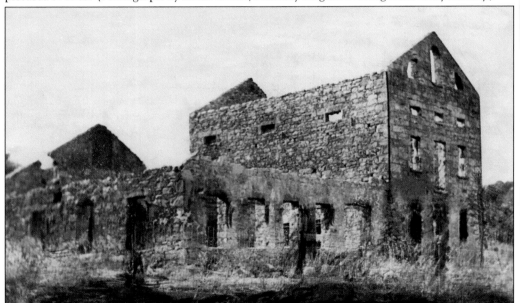

The massive rhyolite brewery building on Church Street was initiated in 1855 by J. C. Gebhardt and later expanded by Henry Hemmighofen and Peter Suessdorf. It produced 2,250 gallons of lager beer each week, utilized old mining tunnels dug into the hillside for cooling, and boasted an outdoor beer garden. Prior to its abandonment in the 1930s, it was used briefly as a cannery. (Courtesy Mokelumne Hill History Society.)

Little remains of this once-bustling town named for Mexican Jesus Maria, who raised vegetables and melons for the miners. The community was settled in the early 1850s by Mexican, French, Chilean, Spanish, and Italian placer miners who worked the gravels of Esperanza and Jesus Maria Creeks and the Calaveras River. (Courtesy Calaveras County Historical Society.)

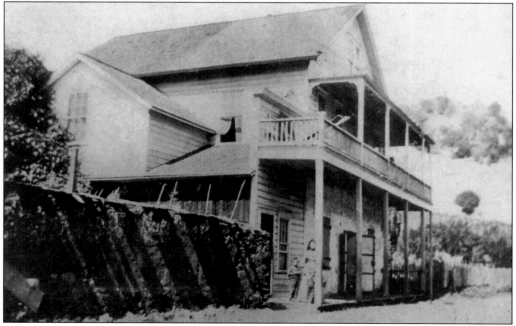

Jesus Maria consisted of one long street with businesses on either side. It boasted mercantile stores, butcher shops, a livery stable, blacksmith shop, hotel, and school. One of the last remaining buildings in town was the Gnecco home, with Louisa Gnecco and her son seen here posed under the veranda. (Courtesy Tiscornia family.)

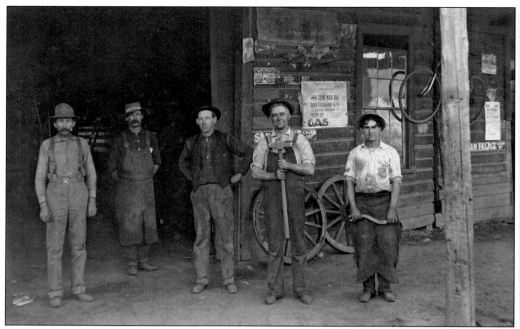

The tides of Paloma rose and fell with the nearby Gwin Mine. The town was originally named Fosteria for Benjamin Franklin Foster, the first owner of the land. It was renamed Paloma for a nearby mine, which was later developed as the Gwin. In this photograph, men gather in front of William Schwoerer's store. (Courtesy Calaveras County Historical Society.)

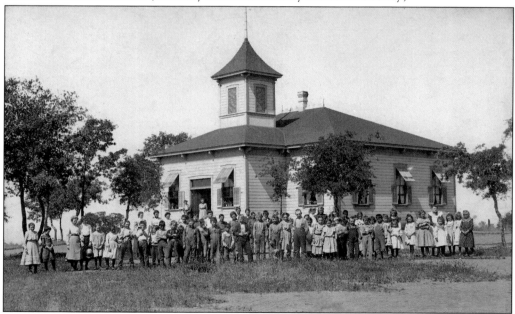

A crowd gathers in front of the Paloma schoolhouse, the last one-room school in the county. It was constructed in 1888 on land donated by George Markwood Sr. for a cost of $2,000. To ward off persistent woodpeckers, the building was sheathed in tin. Closed in 1963, it is now privately owned. (Courtesy Calaveras County Historical Society.)

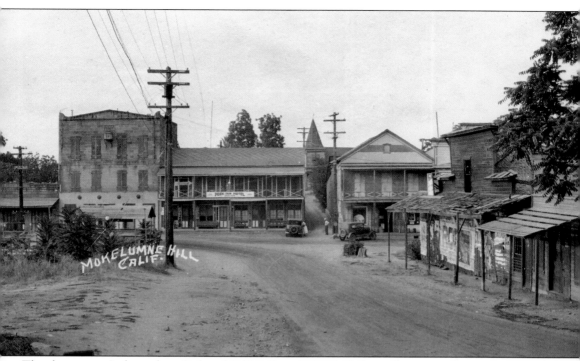

The three-story Independent Order of Odd Fellows (IOOF) Hall was first erected as a two-story stone building by Adams and Company bankers shortly after the fire of 1854 left the town in ashes. In 1860, the Mokelumne Hill IOOF Lodge No. 44 purchased it, and the third story was added in 1861. Throughout the years, the building was shared by various fraternal organizations, the Wells Fargo Express Company, and town merchants. To the right of the hall was Daniel Lamphrey's United States Hotel (1854), which evolved to the Golden Eagle Hotel (1863); the Mariposa Hotel; and finally to the Peek Inn. This last business operated until the 1940s and carried the name of the pioneering families of W. P. and S. C. Peek. Across Sturges Alley (Peek Circle) was the stone store built and operated by H. M. Sturges in 1854. After several changes in ownership, it was purchased and operated by the Frank W. Peek family as a general merchandise store and post office from the 1880s through the 1920s. Behind the Sturges building can be seen the steeple of St. Paul's Episcopal Church—founded in 1895 and gone by 1940. The Lombardi and Danz blacksmith shop on the right is the present site of the town's library and archive. (Courtesy Mokelumne Hill History Society.)

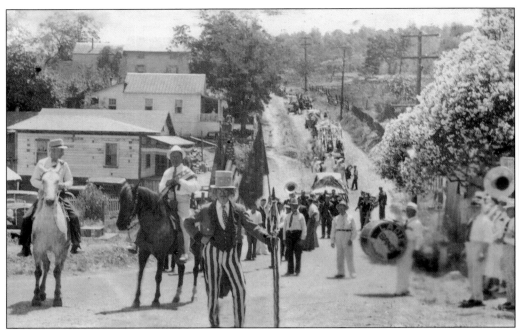

Mokelumne Hill is proud of its long tradition of Independence Day celebrations. This Fourth of July parade, led by a dapper Uncle Sam in 1939, traveled down Church Street to Main Street, just as it does today. (Courtesy Mokelumne Hill History Society.)

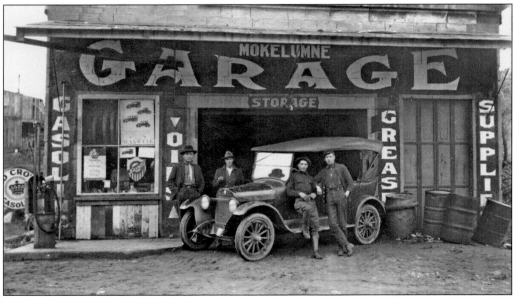

The Mokelumne Garage, owned by Frank W. Peek, was prominently located on West Center Street in the 1920s. The rhyolite stone building was constructed by Levinson in 1854 and originally featured four sets of French doors with iron shutters; the center two doors were removed to open the front up for cars. By 1865, the building was leased by Wells Fargo and Company, by which name it is now popularly known. (Courtesy Mokelumne Hill History Society.)

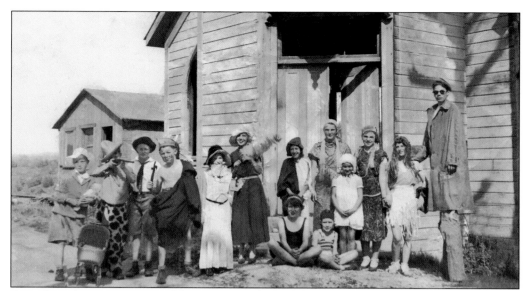

Attendees of a costume party celebrating Pep Peek's birthday in about 1934 posed in front of St. Paul's Church. Pictured from left to right are Chuck McDonald, unidentified, Ivy Dahl, Dean Solinsky, unidentified, Dorothy Lindstrom, Hazel Lloyd (Yocom), Barbara Solinsky, Mary Jane McSorley (Garamendi), Patsy Peek (Steinberg), Marjory DeMoss, Ann McSorley (Murphy), Molly McDonald, and Pep Peek (on stilts). Pep and many of these friends and their descendants still live in Mokelumne Hill. (Courtesy Mokelumne Hill History Society.)

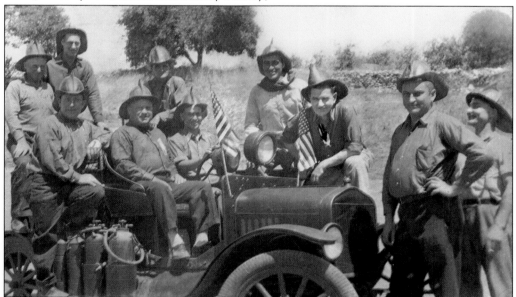

The Eagle Hook and Ladder Company was organized in October 1861, followed a few months later by an additional two engine companies, The Eureka No. 2 and the Pennsylvania. These three companies provided fire protection services to the town in its early decades. This c. 1939 photograph of volunteer fire department members dressed up with their engine for a Fourth of July parade includes Charlie Lavezzo and Bill Maasberg (far left standing), and Pete Morenzoni (riding shotgun). (Courtesy Mokelumne Hill History Society.)

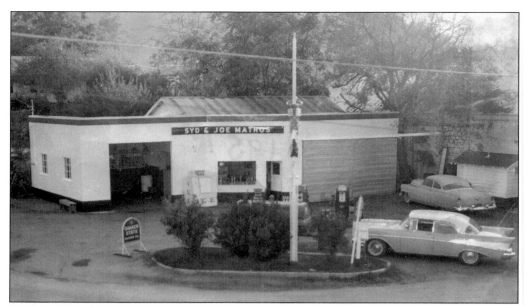

By the 1950s, the town's service station had moved to the corner of Main and Center Streets, owned by Syd and Joe Mathos. The Mathos' garage was transformed into a restaurant in the 1960s, and now serves food to the downtown crowd. (Courtesy Mokelumne Hill History Society.)

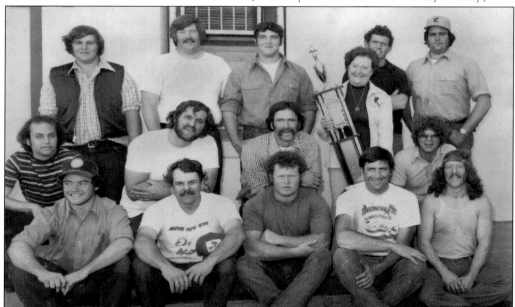

California's current lieutenant governor and former state senator, John Garamendi, early exhibited his competitive skills at the annual St. Patrick's Day Tug-O-War between Mokelumne Hill and Jackson. The winning team in 1978 was, from left to right, (first row) Kevin McCartney, Dick Fischer, Phil McCartney, John Garamendi, and Mike McCartney; (second row) Jeff Tuttle, Tim Fitzpatrick, Bob Garamendi, Capt. Kathleen McCartney (holding the trophy), and John Lavaroni; (third row) Charlie Overmier, Mike Giannini, Clifford Overmier, coach Pat McCartney, and Barry Tarbat. (Courtesy Mokelumne Hill History Society.)

He's local politician
- Mom goes to the Garamendi picnic every year

70

Five

SAN ANDREAS AND RIVER CAMPS

In the winter of 1848, a few Mexicans encamped at the works of the Gulch about one-fourth of a mile above where the town now stands, and commenced working in the bed of the Gulch by sinking holes and working out with bateas. In the fall of 1849, their number was considerably increased, but the place was not looked upon as worthy of any great note as a mining locality. In the winter of 1849, or spring of 1850, a few Americans came in and commenced operations in the main gulches, which soon had the tendency to bring in others.

—*San Andreas Independent*, September 24, 1856

During its early boom years, gold in San Andreas was mined from stream placers and from the Tertiary river channels coursing northwesterly through the town. The early streets were named Spanish Avenue, French Street, and China Street, reflecting the large foreign-born population. In 1853, three stone buildings were erected, the first fireproof structures in the town. The fire of February 1856 burned all but the stone buildings on Main Street, but the others were soon rebuilt, and yet again after the fire of 1858. Prosperity was brief, however, for the *San Francisco Bulletin* reported on May 14, 1865: "San Andreas may be considered as a kind of capital for the mining region of the Calaveras, and its present condition may be briefly described by saying that it has 'caved in.' It has been a place of consequence. Many of the buildings are of brick or stone with iron shutters, etc., but most of these and many of the frame buildings are untenanted. Our landlord told us that there were none but Chinese working in the placers."

All this soon changed, for in 1863, the county's residents voted to establish the county seat which had previously been moved from Double Springs to Mokelumne Hill, to Jackson, and back to Mokelumne Hill, in San Andreas. This move created another building boom in the small community, for homes for the employees who staffed the county offices, and for the additional business and professional people who moved to San Andreas to serve them. From then on, the town's population remained relatively stable to the turn of the 19th century, with the next boom period coinciding with the opening of the hard rock gold mines north of town, primarily the Ford and the Fellowcraft, as well as in nearby camps.

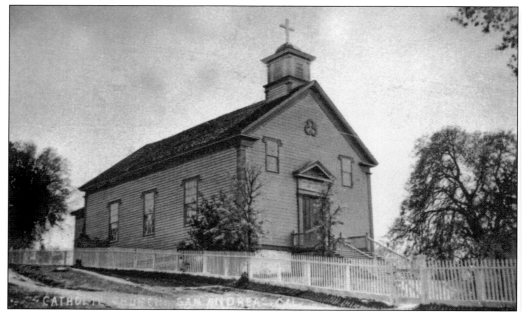

In 1852, a tent church with a simple cross over the door was established by Fr. John Bobard, who was sent to the community by Archbishop Alemany. The church was named for St. Andrew (San Andreas), and the name of the town was taken from the church. In 1857, a new church was completed, and noted as "located on an elegant plateau, affording, from the portico, a most beautiful view of the camp and surrounding country." The present church was dedicated in 1956. (Courtesy Calaveras County Historical Society.)

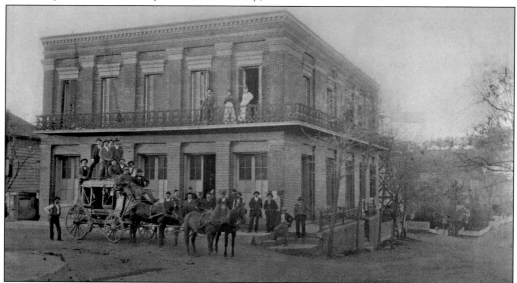

In 1852, the Main Street House, operated by African American Philip F. Piper, opened. Others followed suit, but by far the most elaborate was the 1859 Metropolitan Hotel. A brick building, it had 30 guest rooms and was used as a meeting place for community events and as a stage depot, remaining as such until it was destroyed by fire in 1926. A movie theater was built on the site, now the location of the Metropolitan. (Courtesy Calaveras County Archives.)

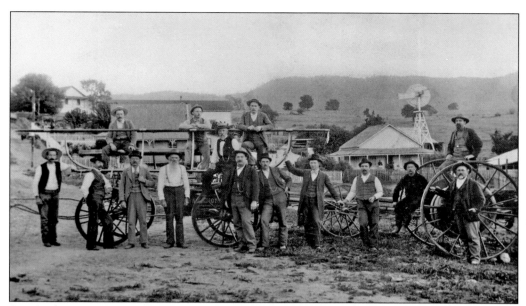

San Andreas experienced its share of fires, so after the big fire of 1858, a public meeting was held to organize a fire department, the San Andreas Protective Hook and Ladder Company. Cisterns were constructed, a fire company organized, and a firehouse erected. In 1862, a new side-stroke engine arrived, celebrated with a parade and grand ball. The hand pumper "Blue Boy" is still maintained by the San Andreas Fire Department. (Courtesy Calaveras County Archives.)

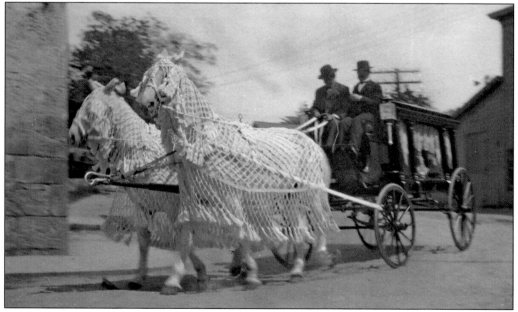

In the earliest days, people were buried wherever it was convenient to dig a grave. In 1859, the Peoples Cemetery was established for those of the Protestant faith and the lodges. On the opposite hill, St. Andrews Catholic Cemetery was established two years previously, while others were located at the county hospitals. This view is of the fine imported hearse of the San Andreas Casket Company, Undertakers and Embalmers. (Courtesy Calaveras County Archives.)

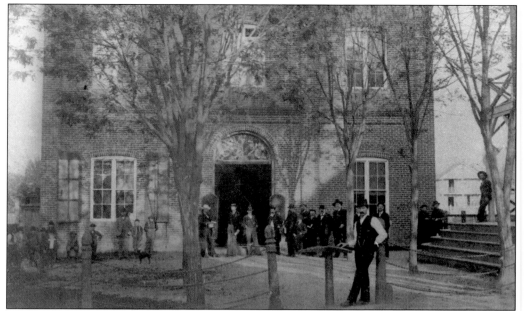

In 1863, Calaveras County voted to move the county seat, located in Mokelumne Hill, to San Andreas, as the Hill was too far from the county center. The move was accomplished in 1867, and a new courthouse erected at a cost of $14,000 by D. L. Morrill. The two-story, brick, Greek Revival building is located behind the Hall of Records and houses the Calaveras County Museum, with the courtroom used as an overflow court. (Courtesy Calaveras County Historical Society.)

With the county experiencing a boom because of the development of the hard rock mines during the "second gold rush" that began in the 1880s, additional office space for county offices was needed. In 1893, the county board of supervisors hired the eminent San Francisco Bay Area architect William Mooser to design the Romanesque Hall of Records in the front yard of the courthouse. In this view, county officials, including Sheriff Ben Thorn and Judge Victor Gottschalk, pose in front of the marble archway. (Courtesy Calaveras County Archives.)

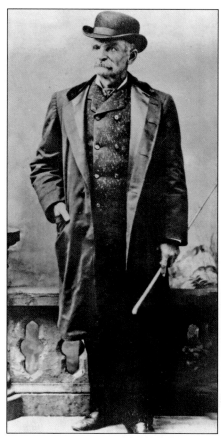

The most unusual and most romanticized bandit operating in the region was Black Bart, the "PO8" (the signature he used on his holdup notes, an acronym for "poet"). A poet and a gentleman, in San Francisco, where he lived, he was known as Charles E. Bolton, a mining man. He was credited with 28 holdups but claimed that his gun was never loaded and that he never shot a man. In November 1883, Black Bart held up the Sonora to Milton stage at Funk Hill near Copperopolis, leaving behind a handkerchief with a laundry mark, which investigators traced to San Francisco where he was arrested. He was returned to San Andreas, tried, convicted, and sentenced to six years in San Quentin Prison. At the county jail, Bart was incarcerated in a cell even more forbidding than this of the trustee. Outside in the jail yard, scaffolds were erected where those condemned to death were hanged. (Both courtesy Calaveras County Archives.)

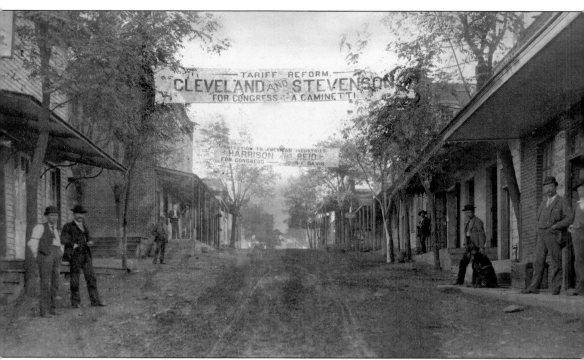

This view, looking south down Main Street in San Andreas, was taken in 1892, the year that Grover Cleveland and Adlai E. Stevenson were running for office. Simple Greek Revival brick buildings dating from after the fire of 1858 lined both sides of the street, which was shaded by black locust trees. The Friedberger Store and present Black Bart Inn are on the right, and the American Hotel, Steele's Boot Shop, and IOOF Hall are on the left. (Courtesy Calaveras County Archives.)

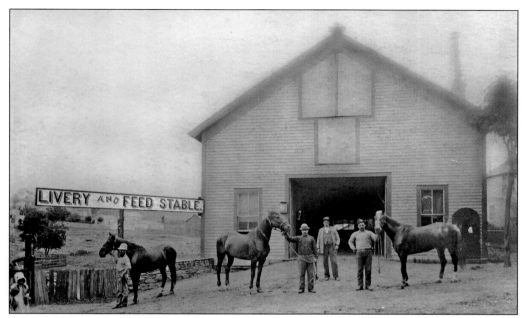

Located on the east side of lower Main Street, J. F. Washburn's Union Livery Stable was one of several which operated in town during the years when the horse and buggy was the primary mode of transportation. In the late 1850s, there were three liveries in town, and by the mid-1880s, there were still three, the Union Livery Stable, Phoenix Livery Stable, and that of the Dasso Brothers. (Courtesy Calaveras County Archives.)

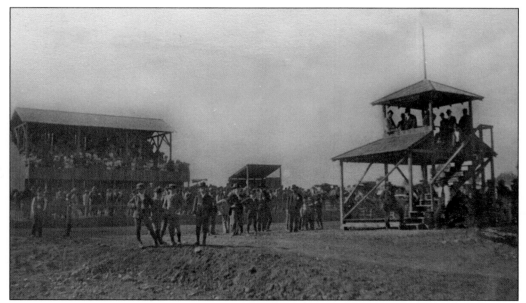

Horse racing was a favorite sport in San Andreas in the mid- and late 1800s, attracting large and enthusiastic crowds. Two racecourses were constructed in early years, one on the Andrew Scieffard Ranch west of town, and another on the old Plug Ugly mine property. This photograph of the racetrack at the San Andreas Fair Grounds was taken in 1936. (Courtesy Calaveras County Archives.)

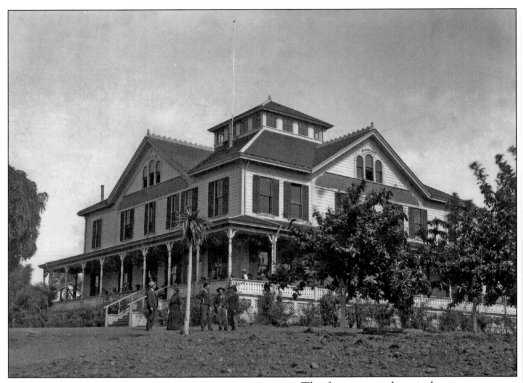

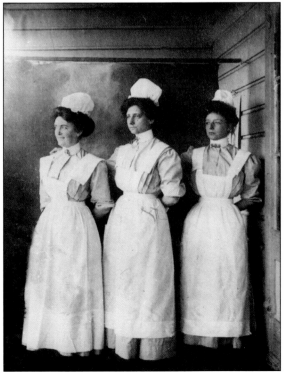

The first county hospital was established at Pleasant Springs in 1858, and remained there until 1869, when it was moved to the Gold Hill Road House west of town. In 1890, the Board of Supervisors purchased land east of town and erected a new, two-story frame building that served the county until the Mark Twain District Hospital was dedicated in 1951. The present Government Center is located on the old hospital grounds, with the "Red Barn" dairy and the hospital cemetery, where the remains of nearly 600 Calaveras pioneers are interred, the only traces of its former function. In this view, three serious and well-uniformed nurses pose for the photographer on the porch of the elaborate Queen Anne–style county hospital. (Both courtesy Calaveras County Archives.)

One of the leading attorneys of the Calaveras bar, Arthur Ignatius McSorley was born on the family ranch near Chile Gulch. He served as justice of the peace, then as a law partner with Judge Ira Hill Reed and was appointed district attorney. In an early letter to his brother and sister, he noted that he was hired "at a salary of $1,400 per year, and $25 for every conviction, not to exceed in all, $500." The family still resides on the ranch, now known as the Garamendi-McSorley Ranch. (Courtesy Calaveras County Historical Society.)

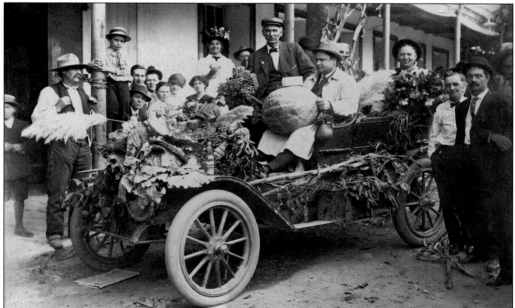

In 1908, as the publisher of the *Prospect*, Clarence Getchell (holding melon) decided he should own one of the new gas buggies and purchased a Studebaker touring car. One of his first trips was to Lake Tahoe with Jake Snyder and George Treat (both in the car with Clarence). On their return trip they stopped at the Sacramento State Fair and picked up some of the county booth's agricultural display, which brought out a large, welcoming crowd when they paused in Mokelumne Hill. (Courtesy Calaveras County Archives.)

Established in 1904, the Calaveras Union High School District initiated classes in 1905 on the first floor of the new Odd Fellow and Masonic building. There were 44 students in the first class, 26 in the academic division and 18 in the commercial (or vocational) division, with Maude Newland the first graduate in 1910. By 1926, the school had grown so that the hall was no longer adequate, and the board of trustees purchased land and raised $125,000 to construct a new building two years later. In 1956, a $550,000 bond issue was passed to construct a new campus. By 1908, the school boasted a girls' basketball team, with two male coaches, which played against Bret Harte and other high schools in the area. (Above courtesy Calaveras County Historical Society; below photograph by Edith Irvine and courtesy Brigham Young University Library.)

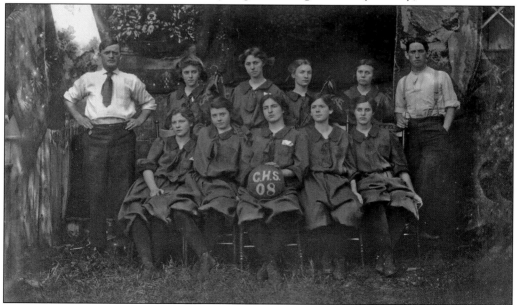

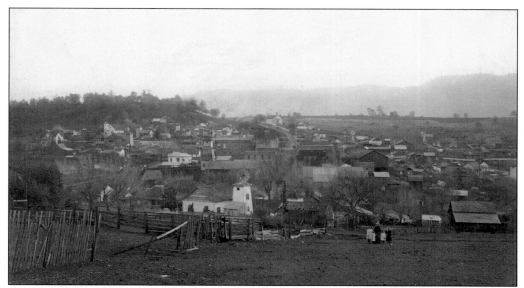

This view of San Andreas at the start of the 19th century was taken from the hill north of town, with St. Andrews Church on the opposite hill. After the early miners' ditches discontinued supplying water to the town, the underground channels were tapped for water but went dry in summer. Wells were then sunk and water pumps operated by windmills were erected all over town; the water was pumped to tank houses for storage. (Courtesy Calaveras County Archives.)

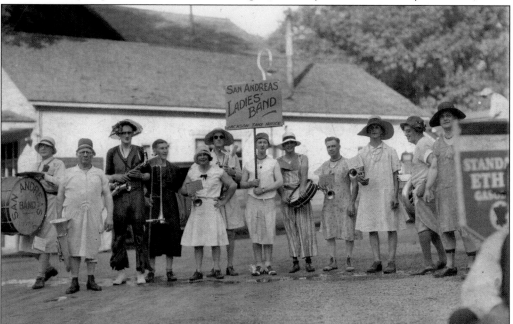

Bands were especially popular in the gold country, with each community, and some lodges, outfitting their members in dress uniforms. Usually featuring brass instruments, the first San Andreas band was organized in 1860 and played for many years at all the local civic, fraternal, and social events. The San Andreas Ladies Band, however, was composed of a ragtag band of men dressed in women's clothes but were nonetheless entertaining. (Courtesy Calaveras County Archives.)

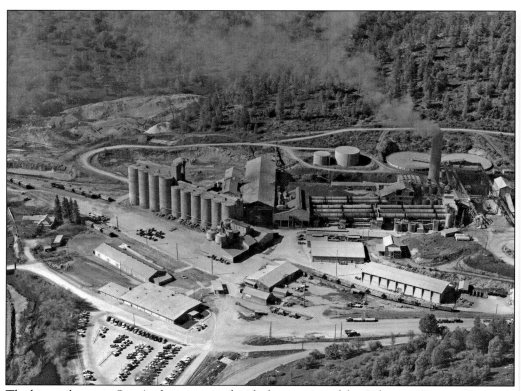

The biggest boom in San Andreas occurred with the opening of the Calaveras Cement Company plant in 1926. Homes were built for the employees, commercial properties were developed, lands were subdivided, and many older buildings were remodeled to reflect the Mission Revival architecture then in vogue. The plant closed in the early 1980s and has since been demolished. (Courtesy Calaveras County Archives.)

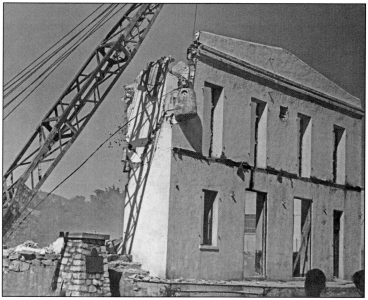

Built in 1881, the stone Colombo Hotel was constructed by Lorenzo and Maddelana Oneto, natives of Chiavari, Italy. After Lorenzo's death in 1896, Maddelana and her five daughters continued to operate the hotel until the 1930s. In 1955, a wrecking ball finally brought an end to the historic structure, one of several stone buildings demolished for the realignment of Highway 49. (Courtesy Calaveras County Historical Society.)

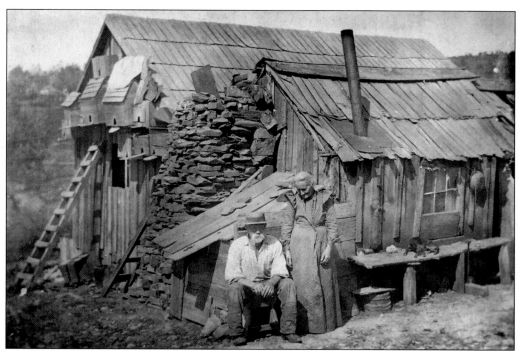

West of San Andreas, Bear Mountain, a remnant of the ancient Sierra Nevada range, stretches north to south through Calaveras, separating its upper reaches from the blistering heat of summer and the damp fogs of winter. A large, inaccessible, and often-forbidding area, nonetheless, well over 100 homesteads were filed on the mountain in early years. The picturesque Bear Mountain home of the Meyers family appears to have organically sprouted from the landscape. Below, a few Osage orange trees are all that mark the site of Mountain Gate, situated on the old Stockton and Mokelumne Hill Road (Highway 12) in the pass through Bear Mountain. In later years, a roadhouse, using the same name, was built about one-half mile east. (Above courtesy Wally Motloch; below courtesy Calaveras County Archives.)

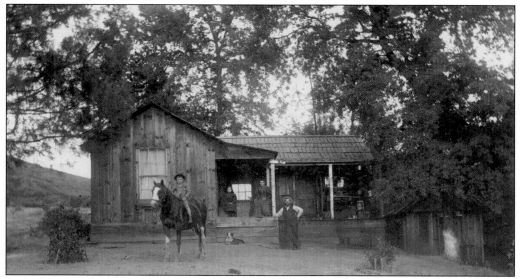

By 1848, the Calaveras River had become dotted with mining camps, several of which developed into permanent settlements. By 1858, the community of Petersburg had a store, billiard room, and a number of families in residence. When the placers played out, the area became an active farming community but was inundated when Hogan Dam was built in 1929. During its heyday, however, this footbridge provided access to Petersburg on one side of the Calaveras and the farms on the opposite bank. (Courtesy Calaveras County Historical Society.)

Located on the Calaveras River, North Branch was almost across the road from the old Pioneer Cemetery. During 1848–1849, as many as 300 miners were working the river in this vicinity. A nearby settlement was Iowa Log Cabins, where, in October 1849, the first miners' meeting in the county was held. Second Crossing, the site of the first toll bridge in the county, and Latimer's Store were other active local communities. (Courtesy Calaveras County Historical Society.)

Also known as Third Crossing, as it was the third crossing of the Calaveras River between Stockton and Murphys, the Kentucky House was the headquarters of miners on the South Fork of the Calaveras. The Calaveras Cement Company later used the property as a clubhouse. The building was demolished in the 1990s. (Courtesy Wally Motloch.)

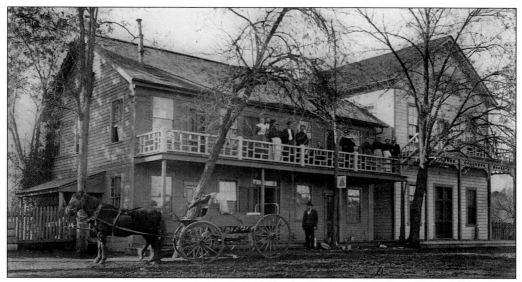

First known as Foreman's Upper Ranch, by 1848 a ferry and hotel were operating at Fourth Crossing to serve the miners on San Antonio Creek. Later a toll bridge, store, and saloon were added, as the crossing became an important rest stop on the route to the Southern Mines. During the 1860s and 1870s, nearly 200 mining claims were operating in the district, and in 1861, William Reddick, then proprietor of the place, contemplated "erecting a new and commodious hotel." Reddick's son, John B. Reddick, became lieutenant governor of California. (Courtesy Historic American Buildings Survey.)

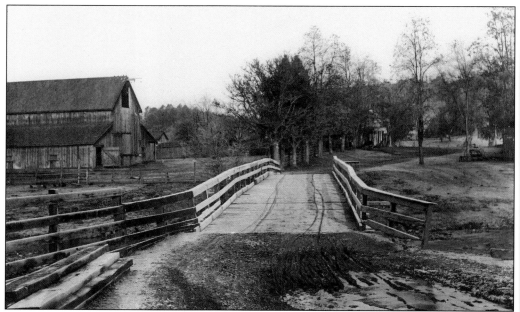

The Fourth Crossing Toll Bridge over San Antonio Creek is the oldest bridge continuously in use in California. Its stone footings were constructed in 1857. The toll bridge remained in operation until 1888, when it was taken over by the county and opened to free traffic. The old route of the Mokelumne Hill to Columbia Road was bypassed by the construction of present Highway 49 in the 1950s. (Courtesy Calaveras County Archives.)

In the early 1850s, San Antonio Camp was a booming mining community, with a commercial section consisting of saloons, gambling houses, dance halls, and stores; by 1859, the placers were played out and the camp deserted. A few families and miners struggled on, notably the Cuneo family who operated a two-story, stone store. The camp is renowned as the location of "Buster's Gold," reputedly buried by a black miner named Dan Buster and searched for by generations of treasure hunters. (Courtesy Calaveras County Historical Society.)

The history of San Antonio Ridge is inextricably tied to the tenure of Desiré Fricot, a French mining engineer who was involved in mining and farming activities in Calaveras County from the 1890s until his death in 1940. As a philanthropist, humanitarian, and conservationist, Fricot was responsible for building and donating Boy Scout huts, was a passionate supporter of the Calaveras Big Trees, and was a founder of the Calaveras County Chamber of Commerce, Museum, and Library. (Courtesy Calaveras County Archives.)

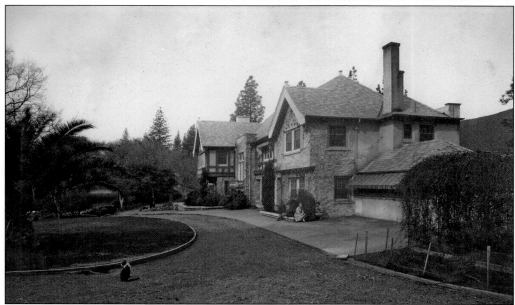

The Fricot Mansion, completed in 1920, was home not only to Desiré and Lillian, but also to family members, various cooks, servants, builders, and old-time miners. For over 40 years, Fricot provided employment on his ranch for many local people, as well as housing and employment for members of the Mi-Wuk tribe. Upon his death, the site became a California Youth Authority campus and now houses the Sierra Ridge Academy. (Courtesy Calaveras County Archives.)

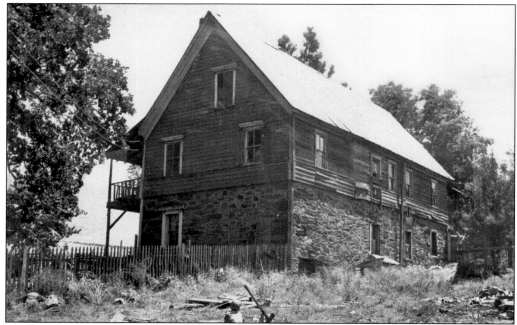

The Mountain Ranch was constructed in the early 1850s and operated as a supply store. A one-story stone building, it served the growing community of miners and farmers for several decades. In the early 1880s, a second and third frame story was added to the building. In 1924, Howard and Margaret Joses acquired the ranch, cleared the land, and raised cattle, sheep, horses, and Angora goats. (Courtesy Wally Motloch.)

El Dorado or Eldorado Camp, known today as Mountain Ranch, was an early-day trading center for nearby quartz and drift mines. By 1871, it was noted as a "decayed mining town," but by the late 1890s several stamp mills were noted as in operation. Attilio Domenghini delivered groceries and other staples from his stone store, one of three in town, from his delivery wagon and team. (Courtesy Fred Kenney.)

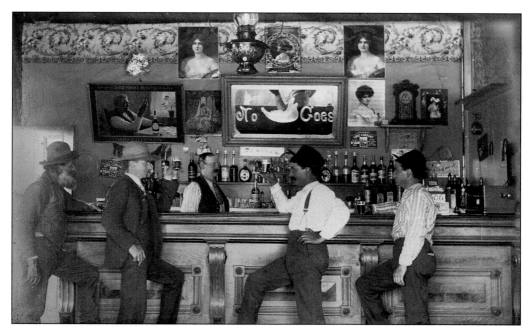

Saloons were the primary recreation spots for miners in the early days, and numerous "watering holes" were established in every community, often in conjunction with hotels and boardinghouses. In the early 1900s, these gentlemen "bellied up to the bar" in the Raggio-Dughi Store in El Dorado. (Courtesy Calaveras County Historical Society.)

Named for the large limestone cave discovered in 1850, the Cave City community that grew up on McKinney's Creek was home to hundreds of miners in its earliest years. When the placers played out in the 1860s, the "Mammoth Cave of California," became the center of activity. A hotel was established by 1854, and a new hotel completed in 1882. Operated as California Caverns today, the cave is now a State Historic Landmark. (Courtesy Wally Motloch.)

we can go here
if you want!

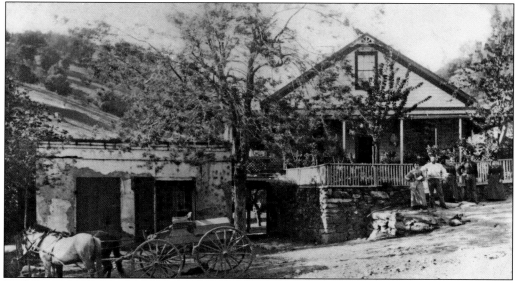

Both Lower and Upper Calaveritas were established by Mexican miners around 1849, with the earliest buildings in (Upper) Calaveritas of adobe construction and housing gambling and fandango houses, stores, and other commercial enterprises. In 1858, most of the town was destroyed by fire, but the store of Luigi Costa continued in operation through the 1930s hydraulic mining period. Owned by the intermarried Costa and Cuneo families, the residence and store remain one of the showplaces of the county. (Courtesy Calaveras County Historical Society.)

In the late 1920s, the Calaveras Cement Company constructed a wooden trestle through Calaveritas to access its operations at quarry No. 4 in nearby Old Gulch. When the trestle was built, it was planned to operate trains for hauling, but the ascendancy of the truck soon thereafter precluded construction of the rail line. Another trestle, built of concrete, crosses Highway 49 near the site of Lower Calaveritas. (Courtesy Calaveras County Archives.)

Six

WEALTH FROM WATER

Water has always been of major importance in the development of Calaveras County. Water is essential to recovering gold, so mining originally took place along rivers and their tributary streams. But since foothill rivers are seasonal and unpredictable, entrepreneurs soon constructed dams to store water, with ditches and flumes bringing water to the diggings and allowing for the establishment of camps and towns. Many ditch systems were abandoned as the placers played out, but others were improved and extended for hydraulic and hard-rock mining. With mining's demise in the early 1900s, some shut down while others were converted to agricultural and domestic uses. The expansion of agriculture and demands for domestic water as well as hydroelectric power generation has since made this "liquid gold" ever more precious.

The most important early water system in Northern Calaveras was the Mokelumne Hill Canal and Mining Company, completed to Mokelumne Hill in 1852 and subsequently to Campo Seco, Camanche, and vicinity, a distance of 60 miles. In 1934, the water rights were acquired by the Calaveras Public Utility District (CPUD).

The Table Mountain Water Company, founded in 1853, brought water into El Dorado (Mountain Ranch), Cave City, Old Gulch, and San Andreas. Later known as the Treat Ditch, for owner J. F. Treat, it served these communities until the 1930s. Meanwhile, the Georgia Ditch took water from below the head of the Table Mountain Ditch on San Antonio Creek. By 1858, that ditch was 20 miles long, serving mining camps from Calaveritas to Fourth Crossing. Acquired by the San Antonio Ridge Ditch Company, it is now used by the Sierra Ridge Academy at Fricot City and by the community of Sheep Ranch.

Businessmen with an eye to the future began developing hydroelectric projects in the late 1890s. On the Mokelumne River, the 1897 Blue Lakes powerhouse was later rebuilt upstream as the Electra, and is now one of PG&E's most productive facilities.

In the 1920s, the East Bay Municipal Utility District (EBMUD) began damming the waters of the Mokelumne River to provide water for its users. Pardee Dam was completed in 1929, and Camanche Reservoir was filled in 1962. Along the Calaveras River, farmland and communities were condemned by the City of Stockton to construct Hogan Dam and Reservoir, dedicated in 1931, with New Hogan Dam completed by the U.S. Army Corps of Engineers in 1964. Today these reservoirs bank this wealth not only for Calaveras citizens but for populations farther west.

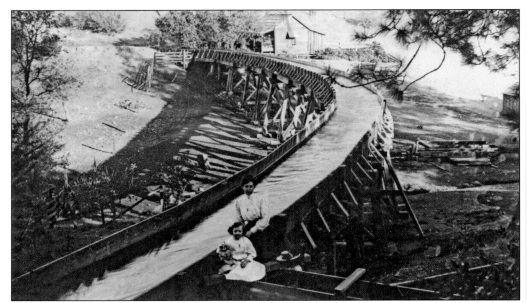

During the 1850s and 1860s, the Mokelumne Hill Canal and Mining Company was the largest supplier of water to the miners in Northern Calaveras. Financial troubles, however, led to foreclosure in 1859 and a major reorganization in the 1860s. By the early 1900s, the Campo Seco portion of the canal had been abandoned and the company was reorganized as the Mokelumne River Water and Power Company. The wooden flume pictured was in use near Mokelumne Hill in the early 1900s. (Courtesy Calaveras County Archives.)

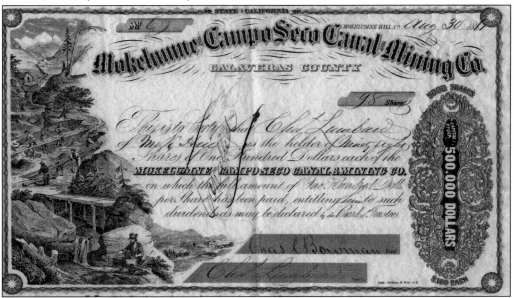

This certificate of the Mokelumne Hill and Campo Seco Canal and Mining Company was issued for $500,000 in stock, a valuable consideration at the time. Under Samuel L. Prindle, the renamed Mokelumne Hill and Campo Seco Canal and Mining Company completed extensions to Chile Camp and Spring Valley (near today's Burson and Valley Springs). (Courtesy Judy and Frank Brockman.)

Located near Big Bar on the Mokelumne River, the Blue Springs Electra Powerhouse was completed by Polish nobleman André Poniatowski in 1897. Within a year, the "Prince" completed a larger, hydroelectric project to power his adjacent mines. With his brother-in-law financier William H. Crocker and others, the investors incorporated as Standard Electric of California. The new, larger plant, the Electra Powerhouse, was located several miles upstream from the Blue Lakes Powerhouse. The system of dams, reservoirs, and powerhouse were acquired by PG&E in 1906, and became its largest producer of power, bringing electricity not only to Amador and Calaveras counties, but also to San Jose and San Francisco. The current power plant was constructed in 1947–1948. (Courtesy Mokelumne Hill History Society.)

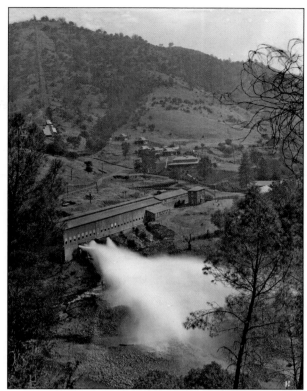

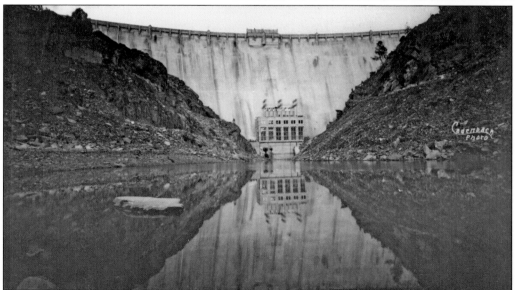

Created in 1923, the first priority of EBMUD was to locate distant river sources for water. With former governor George Pardee as president, the district began preparations for the construction of a dam and reservoir on the Mokelumne River near the site of Diamond Bar. Work on Pardee Dam began in 1927, with a branch railroad constructed to San Andreas to link the cement plant with the dam site. The dam was completed in 1929. (Courtesy Calaveras County Historical Society.)

Probably named for a town in Iowa, by 1858, with the mines paying well, Camanche Camp boasted four grocery stores, two clothing shops, two hotels, two blacksmiths, two drug stores, a meat market, and billiard rooms and whiskey mills in abundance. From the late 1870s, most of the town was Italian, with the stone Cavagnaro Store the center of the community. The major agricultural crop was a type of chrysanthemum used in the production of the insecticide Buhach. (Courtesy Calaveras County Historical Society.)

In 1959, EBMUD received final approval for the Camanche Dam project, and the dam was completed in 1964. The historic towns of Lancha Plana, Camanche, and Poverty Bar, as well as many farms and ranches, were inundated. Known pioneer graves were located and moved, several to the Pioneer Cemetery near San Andreas. Today numerous Native American villages, Gold Rush camps, and these early towns still lie quietly beneath the waters. (Courtesy Wally Motloch.)

Seven

UP-COUNTRY COMMUNITIES

The up-country areas of Northern Calaveras have been isolated for nearly 100 years by distance and temperament. The steep mountain canyons made travel difficult, and the immigrants who stayed were self-reliant folks who liked the remoteness.

High plateaus separated by steep gulches of the Mokelumne River drainage, lying some 1,700 feet below, characterize the topography of the up-country. The plateaus with their gentle slopes and springs were pleasant places to live and supported Native American villages. During the Gold Rush, many of these same locations were occupied by miners and evolved into towns: Rich Gulch, Glencoe, Rail Road Flat, Sandy Gulch, and West Point.

Native American footpaths led eastward, providing the forty-niners access through the rough country. These paths were soon improved into narrow wagon roads with bridges to transport the supplies and machinery needed for hard-rock mining and logging. By 1852, the Mokelumne to West Point Road supported a steam sawmill in Glencoe, and by 1856 the stagecoach ran the entire route in a summer's day. In the winter, the roads were often closed by huge potholes and deep mud. Thus, winter survival in the up-country depended on the harvest and storage of food in the fall by each family.

Up-country people survived as subsistence farmers. A large garden and orchard supplied food that was preserved when it was ripe, while livestock and hunting provided meat. Each homestead was a world of its own, self-contained and self-sufficient. Except for an occasional job in a mine or neighbor's ranch for a dollar a day, money was difficult to come by.

This up-country lifestyle was radically changed at the onset of World War II, when lumber was identified as a critical resource. In the late 1930s and early 1940s, major road improvements and electrification enabled the construction of modern lumber mills. Hundreds of workers immigrated to the area, with the flush times continuing into the 1960s when the mills closed. Now residents are faced with a commute out of the area to find work.

Today there are few signs of the miners, homesteaders, and lumbermen, as the land is being subdivided for retirees fleeing the urban sprawl to the west. We are fortunate that some of our ancestors recorded their lives and hope that this small collection of photographs from their albums will provide an appreciation of our history.

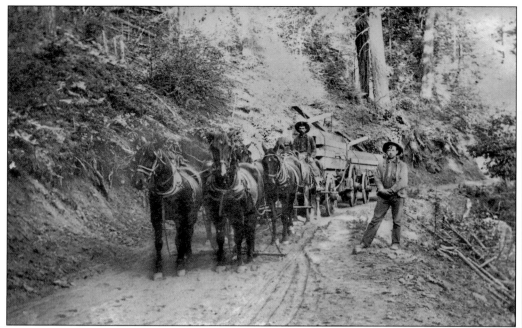

The first dirt roads were built with hand tools and often followed earlier trails. Deep cuts, however, as shown in this photograph, were frequently required when crossing steep slopes. This photograph was taken about 1890. (Courtesy K. Smith, T. A. Wilson album.)

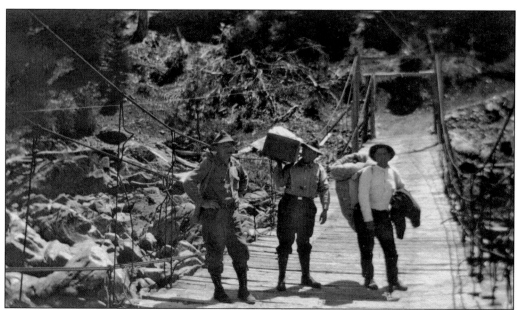

A major obstacle to up-country transportation was the Mokelumne River and its forks. The first bridges, low buttresses often destroyed by floods, were often replaced with suspension bridges hung on cables more than 50 feet above the water. This lagging-and-cable bridge crossed the North Fork Mokelumne about 20 miles east of West Point near Bruce's Camp. Wendell L. Phillips is on the left. (Courtesy K. Smith, T. A. Wilson album.)

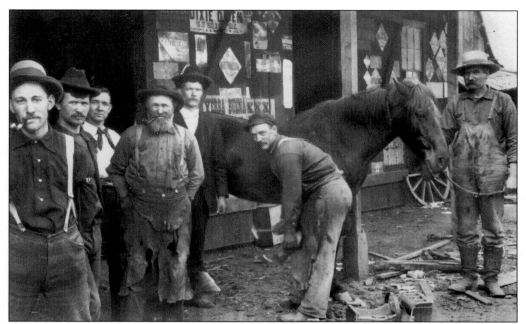

John R. Smith, the bearded man in the middle, ran the blacksmith shop on Main Street in West Point from 1862 to 1904. He served two terms as justice of the peace, two terms as county supervisor, and was an active Odd Fellow for 20 years. (Courtesy K. Smith, T. A. Wilson album.)

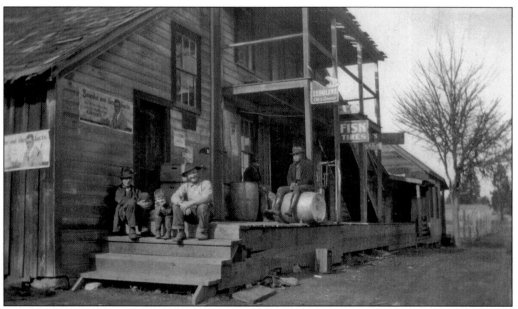

The Taylor Store in Rail Road Flat provided postal services, staples, hardware, a saloon, upstairs dance hall, and a front porch. Homesteaders often traded beans, potatoes and eggs for sugar, flour, salt, green coffee beans, whiskey, beer, and tobacco. With the arrival of the first cars in the early 1900s, a service station was added, providing gasoline from 50-gallon drums on the porch. Arch Lester is on the steps, to the right, and George Smith sits on the drum. (Courtesy Romita Swanson.)

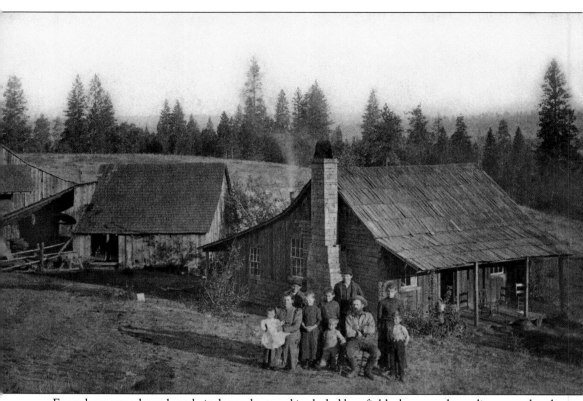

Every homestead was largely independent and included hay fields, large gardens, diverse orchards, and livestock, including milk cows, beef cattle, hogs, and chickens. Fruit and vegetables were stored in root cellars and canned—some 300–400 jars were put up each fall. Abundant game was hunted for meat, and the river and creeks were fished for trout. Members of the Danielson family on Mosquito Gulch in 1893 included, from left to right, Beatrice Irene, Gertrude (mother), Chester Arthur, Emily May, Sidney Roland, Matilda Grace, Theodore Magnus, Sven (father), Daisy Adelia, and Elmer Vernon. (Courtesy Don Ames.)

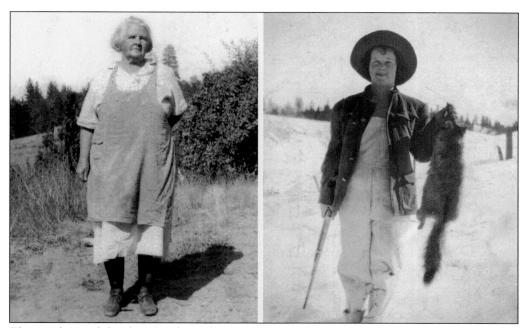

This mother and daughter lived on a homestead in Mosquito where they made clothes, washed on a washboard, ironed, cleaned, gardened, cooked, baked, canned, milked, hunted, and had 18 surviving children between them. Gertrude Danielson lived to be 96, and her daughter Thelma lived to be 85. (Courtesy Don Ames.)

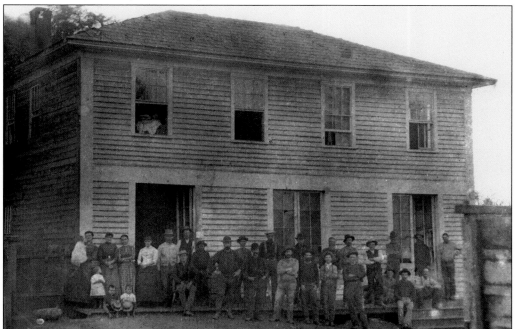

Most towns had a hotel that provided room and board to a transient labor force of miners, loggers, and farm workers. Shown in the mid-1880s is a gathering at John Hoey's Hotel at Pleasant Springs. (Courtesy Don Ames.)

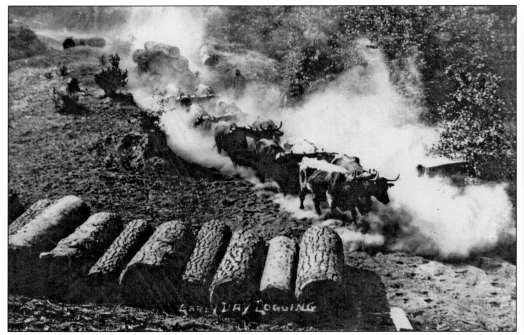

Logs were loaded on wagons in the woods and transported to mills using teams of oxen, horses, or mules. This photograph, taken in 1879, shows dusty, summer road conditions. (Courtesy K. Smith, T. A. Wilson album.)

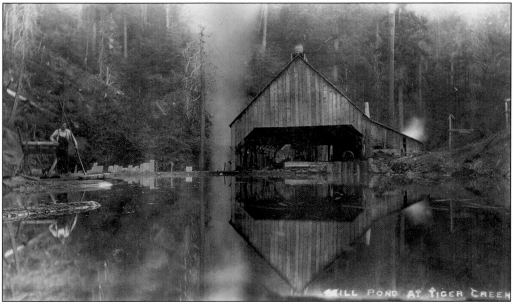

One of the first sawmills was erected in Glencoe in 1852 by the Mokelumne Hill Canal and Mining Company, and it cut 15,000–20,000 board feet of lumber per day. Small mills powered by water and steam soon appeared throughout the region, typically producing siding, shakes, posts, and rails for markets as far away as Mokelumne Hill. This 1920 photograph shows a mill at Tiger Creek near West Point. (Courtesy K. Smith, T. A. Wilson album.)

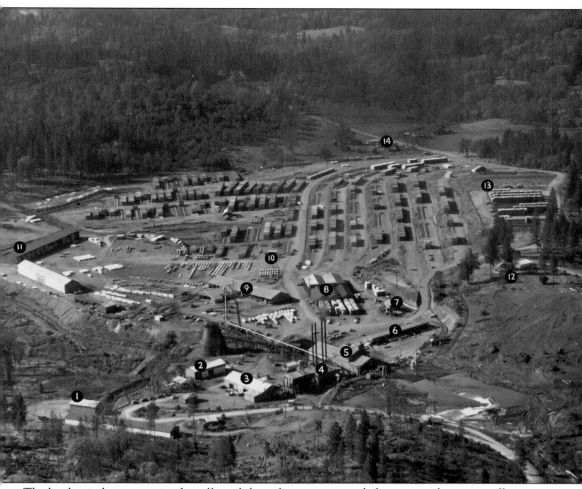

The lumber industry remained small until the infrastructure needed to support large sawmills was developed during the 1930s. While water could be obtained from old mining ditches, electricity from powerhouses on the North Fork—Salt Springs, Tiger Creek, and West Point—was not readily available until about 1940. Old dirt roads were realigned, graded, and paved, and bridges were replaced with reinforced concrete under Roosevelt's New Deal and other public funding programs. Large diesel trucks could now haul lumber from up-country mills to railheads at Toyon and beyond. World War II boosted the economy as large, modern sawmills were built in West Point and Wilseyville to supply lumber, crates, and boxes for shipment worldwide. Labor was recruited throughout the west and housed in company towns. This photograph of the Associated Box and Lumber Company mill was taken in 1944 when it produced 20 million board feet of lumber. The mill occupied 200 acres and had these components: 1. tire shop; 2. Caterpillar repair shop; 3. truck repair shop; 4. boiler house; 5. sawmill and lath factory; 6. green chain (lumber sorting); 7. sticker plant for stacking lumber; 8. dry kilns and cooling sheds; 9. planing mill; 10. yard and shipping office; 11. drying sheds; 12. mill office; 13. fire lookout; and 14. historic Sandy Gulch. (Courtesy Pat Blagen Bradley.)

League play took this West Point team to Rail Road Flat, Mokelumne Hill, Jackson, Sutter Creek, San Andreas, Angels Camp, Paloma, and Wallace. Fans attended in their Sunday best; sat in shaded, wooden bleachers; and adjourned to the local saloon. Baseball has been played at the Taylor Ranch in Rail Road Flat for 150 years, where the dirt field and wooden bleachers can still be seen today. (Courtesy K. Smith, T. A. Wilson album.)

Cemetery Hill, on the ridge overlooking West Point, became a center for winter sports when it snowed. This photograph, taken in 1920, shows handcrafted sleds. (Courtesy K. Smith, T. A. Wilson album.)

Hunting provided sport, sustenance, camaraderie, and an occasion to tell tall tales. This trip, c. 1915, was to Salt Springs on the North Fork Mokelumne River. Artie Wilson recalls that there was plenty of horse feed in the meadows, all the honey you wanted, wild plums, and all kinds of deer, quail, and grouse. (Courtesy K. Smith, T. A. Wilson album.)

There was good fishin' at Bruce's Camp at the confluence of the North Fork and Blue Creek. Pictured above in the early 20th century is a catch of over 200 trout. (Courtesy K. Smith, T. A. Wilson album.)

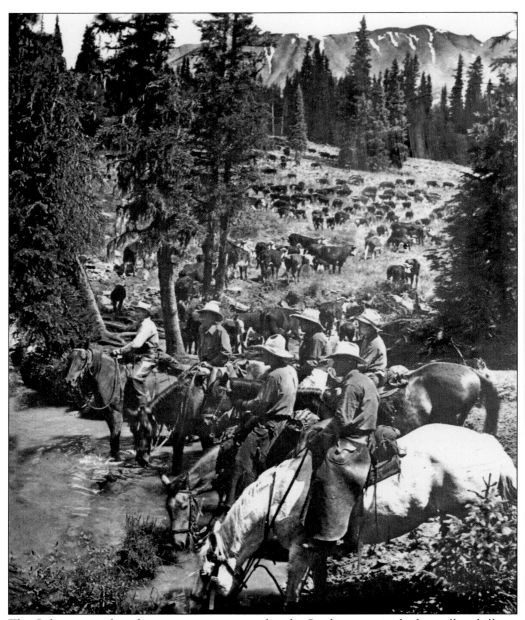

The Calaveras cattle industry runs on an annual cycle. Cattle winter in the low rolling hills on the large ranches of West Calaveras where they feast on green grass. In late spring, when the grass turns brown, thousands of cattle are moved to the high country by ranching families who settle into their camps for the summer. In the old days, the cattle were driven along the roads through the up-country communities, camping along the way. In the late 1960s, cattle drives were replaced with trucks and trailers, to the disappointment of every child on their route. (Courtesy K. Smith, T. A. Wilson album.)

Eight

THE WEST CALAVERAS GATEWAY TO THE MOTHER LODE

Unlike other regions in the Gold Country, the early history of West Calaveras County is not one filled with colorful outlaws, outrageous speculators, or tall tales either of gold or frogs. Instead, its story is one of settlers who came from every part of the United States and many countries around the world—more than a few of them veterans of the Civil War—and who built their lives on 160-acre homesteads.

For most of its existence, this western corridor was a place on the way to other places, such as the world-renowned Big Trees or the large gold mines. Roadhouses such as Tremont House, North America House, Spring Valley House and Pattee's Place linked travelers and freight teams from Stockton and Lodi with San Andreas to the east and Jackson to the north. While gold instigated settlement and copper continued it, particularly at the Penn Mine in Campo Seco, steel, as in the San Joaquin and Sierra Nevada Railroad, created the three towns that formed the "Gateway to the Mother Lode."

The *Valley Review* (June 4, 1884) touted that "this new railroad will prove a great blessing to these people so long shut off from the commerce and manufactures of the world. . . . towns will spring up, and all the advantages enjoyed by the denizens of more favored localities will be meted out to those brave pioneers who have toiled and reared their families on their foot-hill farms contented with their surroundings nor ambitious to enter the arena of fortune to struggle for wealth, honors and fame, though surely the first of these will come without the seeking."

West to east, the towns of Wallace, Burson, and Valley Springs did spring up—added to locales founded in the Gold Rush, such as Jenny Lind, Campo Seco, and Camanche. Valley Springs became a major freight distribution center for the county.

Yet the main occupation of residents remained agriculture. They grew wheat, barley and oats and raised sheep and cattle. They conducted an annual ritual of moving their herds to the mountains up-country during the hot summers and returning them to the valley before winter. Orchards, including olives, were also particularly successful.

For its first 100 years, the West Calaveras Gateway to the Mother Lode embraced those who may have arrived as miners but soon became farmers and ranchers.

A man named John Dudley pitched a tent in 1849 at Double Springs and the next year had frame houses in panel form shipped from China. In 1850, one became the courthouse at the first county seat. In 1854, forty-niner Alexander Wheat purchased the property. In 2006, the courthouse was removed by the Calaveras County Historical Society so that it may be preserved. (Courtesy Calaveras County Historical Society.)

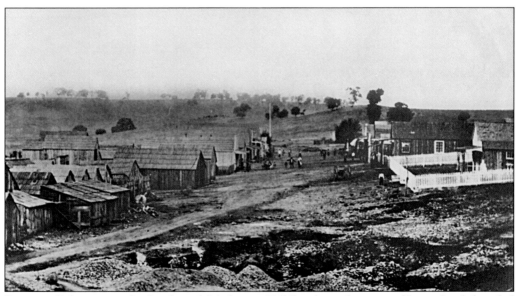

Entering Calaveras on the Stockton-Mokelumne Hill Road was the town of Jenny Lind, founded in 1849 by Dr. John Y. Lind. Presumably a distortion of his name became that of the Swedish singing star. In 1856, the date of this photograph, Jenny Lind boasted four general stores, two billiard halls, two hotels, a bowling alley, blacksmith shop, a church, and several saloons. (Courtesy Calaveras County Historical Society.)

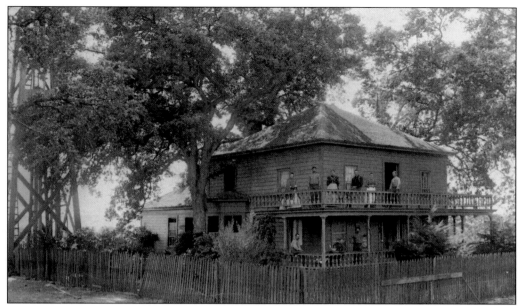

Englishman Mansfield Gregory and his Pittsburgh-born wife, Anna, purchased their Jenny Lind ranch in 1870 and were among the most educated and wealthy of area residents. "The view of the surrounding country is a delight to the occupants of this home, where old time Californian hospitality is dispensed," wrote a 1923 observer. Seven years later, the house (pictured c. 1890s) was destroyed by fire. (Courtesy Calaveras County Historical Society.)

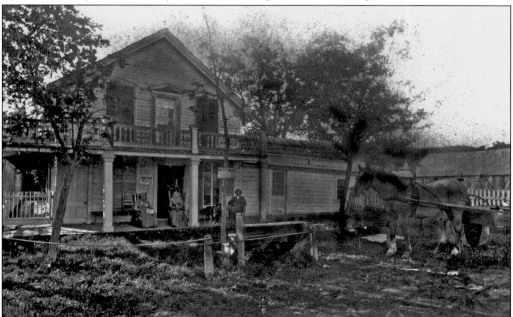

An early stage stop on the road from Stockton, North America House operated from the early 1850s. New Yorkers Tracy (right) and Fanny Stroud (middle) were the owners for the last quarter of the 19th century. The steps in front were for the convenience of stage passengers in this photograph, c. 1894. (Courtesy Calaveras County Historical Society.)

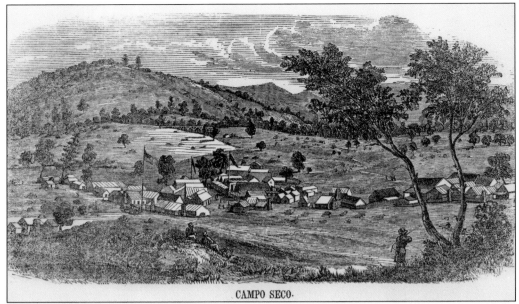

CAMPO SECO.

Campo Seco (Spanish for "dry field") was a placer mining camp serving the bars along the Mokelumne. By winter 1850, a town sprang up, and by 1853, mining laws were adopted. A post office was established the following year and soon a school. Typically, when Euro-Americans departed, Chinese took their place, and a "Chinatown" developed. This view shows the town rebuilt after a devastating 1854 fire. (Courtesy Calaveras County Historical Society.)

Five years later, after again being nearly destroyed by fire, the town was rebuilt, with the ditch of the Mokelumne Hill and Campo Seco Canal and Mining Company providing water. By 1860, it boasted two hotels, two saloons, two churches, five stores, brewery, blacksmith shop, restaurant, livery stable, and a Wells Fargo office. This photograph was taken before the stone and brick buildings collapsed into today's picturesque ruins. (Courtesy Calaveras County Archives.)

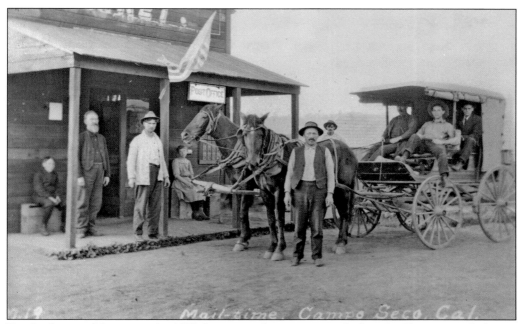

For the future of the town, the 1859 discovery of copper in nearby Lancha Plana proved of more consequence than gold. Shortly thereafter, copper was found in Campo Seco, ushering in a period of booms and busts as the price of copper waxed and waned with its need for shell casings for war efforts. A coach and team are pictured at the market during the early 1900s. (Courtesy Calaveras County Archives.)

In addition to the mining revivals, Campo Seco also experienced another revival when it became host to hundreds of workers during the late 1920s construction of Pardee Dam. At that time, the community boasted four stores, a restaurant, two hotels, a dance hall, and several moonshining operations. A fire that year, and the completion of the dam and the departure of the workers, caused yet another bust. (Courtesy Calaveras County Archives.)

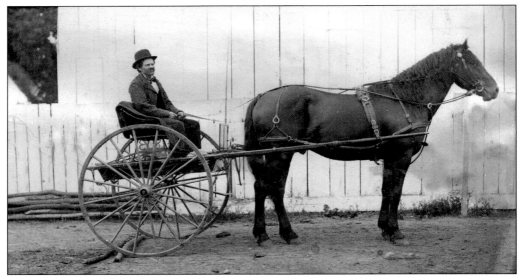

Blacksmith Orange Lillie and wheelwright brother George Bates Lillie (shown in this tintype) came to California from Canada in 1859, arrived in Calaveras County the following year, and settled in what would become Valley Springs. Their hometown sweethearts, sisters Melita and Adella Wickwire, joined them later, with Orange marrying Melita and George wedding Adella. (Courtesy Jack and Jackie Seibold/Schwoerer family.)

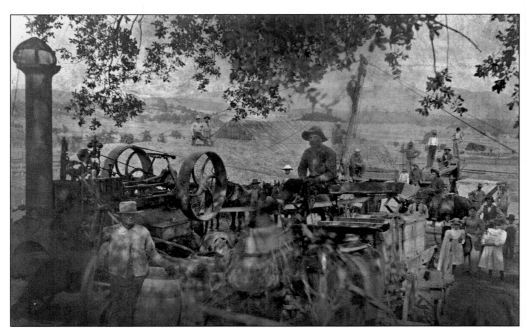

In 1850, the place was known as the Boston Ranch, since it was near Boston Bar on the Calaveras River, at the north end of Weehawken Valley at the western edge of Bear Mountain. Later owned by Giacomo Leoni and then Swiss stonemason John Peter DeMartini, the DeMartini Ranch, shown c. 1890 during a haying operation, is now largely under New Hogan Reservoir. (Courtesy Calaveras County Archives.)

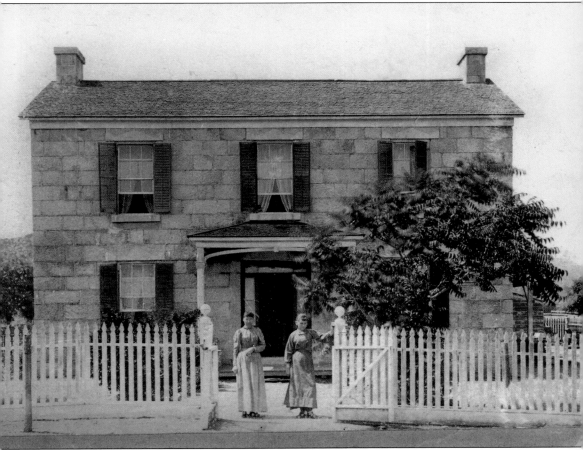

George Late, a forty-niner from Maryland, settled in the mid-1850s in Calaveras County, where he raised a family with his wife, Rebecca. Their house was built *c.* 1862 of local limestone by Scottish stonemason William Watt, who used his initial W in the decoration above each window. In 1884, the Lates sold some 50 of their acres to Frederick Birdsall, president of the San Joaquin and Sierra Nevada Railroad, and upon that land, Valley Springs was founded. Late sons Ira, Oscar, Miller, and John were farmers, entrepreneurs, and solid citizens of the first order. None married until well into their 30s, long after the family patriarch died in 1887. This *c.* 1884 photograph shows daughter Elizabeth ("Libbie"), who never married, on the left and a daughter of the neighboring Reinking family on the right. (Courtesy Calaveras County Historical Society.)

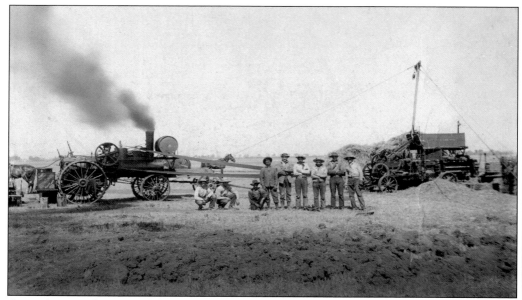

According to the journal kept by Oscar Late, in one week alone in July 1897, the Lates' threshing crew worked at the Lillie, Gelbke, Hannon, White, DeMartini, Gann, and Beal ranches. They are shown at the Late Ranch in Valley Springs around 1900. (Courtesy Calaveras County Historical Society.)

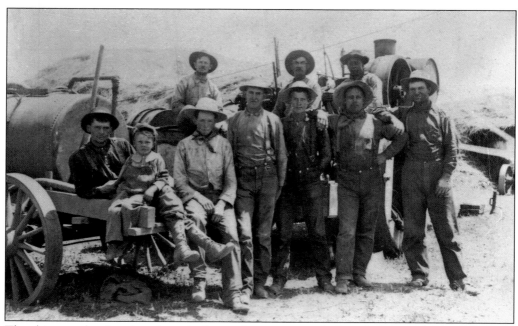

Threshing was hard work and required several men, even with the aid of steam-driven machinery. This *c.* 1900 photograph of men taking a break while threshing in West Calaveras is one of the very few images in early West Calaveras history to include an African American. (Courtesy Calaveras County Historical Society.)

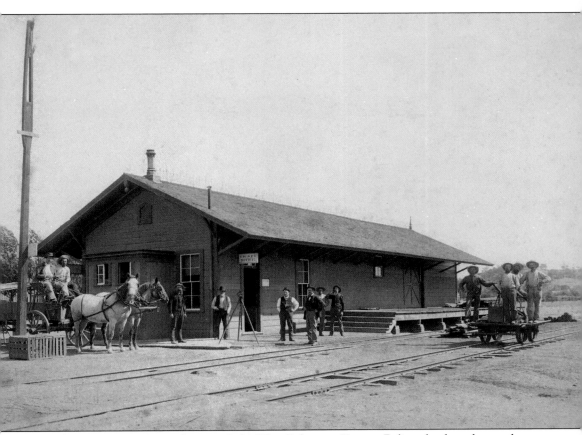

This is the Promontory Point photograph for West Calaveras County. Believed to have been taken in late 1882, depicted is the newly completed Wallace depot of the San Joaquin and Sierra Nevada Railroad (SJ&SN). Note how the railroad tracks are covered with earth as they extend to the left and the lack of freight on the platform though there is still leftover lumber from the construction. Note also the surveyor's tripod at the center. Though the town was named for John Wallace, the railroad's chief engineer and surveyor, the townsite was surveyed by his son, John Herbert Wallace. The man second to the right of the tripod, wearing the coat, may be J. H. Wallace—photographed on the very day the town was surveyed. The man to the far left driving the wagon is T. C. Evans, who built the first hotel in Wallace. (Courtesy Dave Evans.)

A forty-niner from England, John Wallace was a brother of famed naturalist Alfred Russel Wallace, who helped develop the theory of evolution. "A station will be located and the nucleus formed of a town to be named Wallace in honor of Mr. Wallace, the engineer whose efficient work . . . merits this signal honor," wrote the Lodi Sentinel in 1882. (Courtesy Haggin Museum, Stockton.)

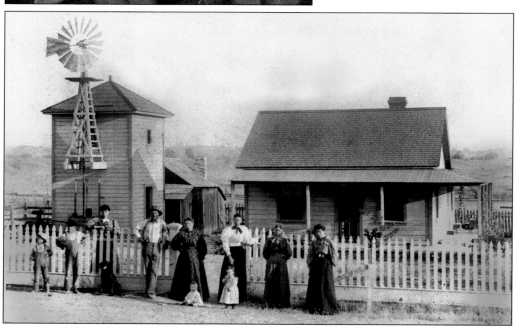

Pictured in 1895 at the Haddock homestead in Wallace are, from left to right, Walter, George, and May Haddock; Romeo the dog; Charles Henry Little; Lecta Little Haddock; Emma Little Haddock; Lizzie Little; and Rose Haddock, plus the children in front, Frank and Arthur Earl Haddock. The latter became a well-known landscape painter and a friend of world-renowned artist Maynard Dixon. (Courtesy Calaveras County Historical Society.)

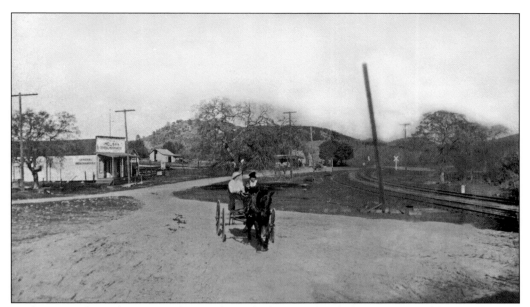

Looking east from the Burson depot, where the buggy is heading, Burson Road lies just beyond the railroad crossing sign. The station was renamed Helisma in the 1890s and both the street shown and the store to the left have that name in this 1917 photograph. The town, however, remained Burson, named after Daniel Smith Burson who founded the town site in 1884. (Courtesy Calaveras County Historical Society.)

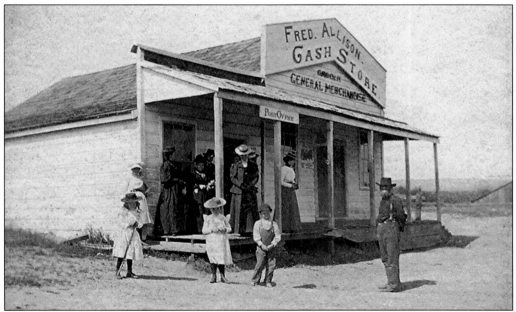

Connecticut-born Fred Allison opened the Allison Cash Store in Burson around 1894, and for nearly 20 years, everyone in the vicinity shopped there. Gold miners reportedly would frequent the store just to weigh their hard-earned gold dust on the grocery scales. The store also functioned as the Burson Post Office, for which Fred was postmaster along with his sister Alida. (Courtesy Howard Allison/Fred Burris.)

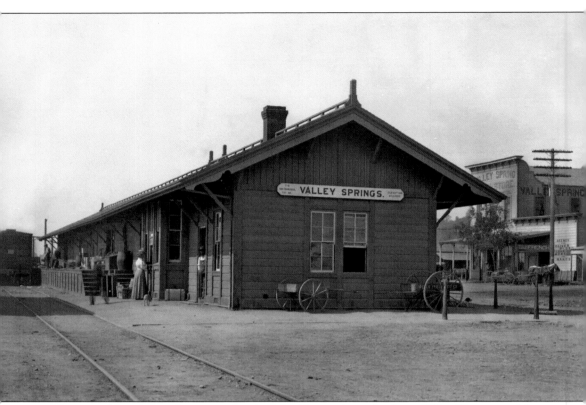

"Come with your shovel, carts and picks / And bring the girls along, / They'll put new life into the thing, / And cheer you with a song, / For they no longer want to go / Upon a poky stage / And they are bound to have a ride / Upon the Narrow Gauge," read a poem in an 1883 issue of the *Mountain Echo* newspaper. The railroad reached Calaveras County at Wallace in 1882 before moving on to Burson in 1884 and Valley Springs in 1885. "This flourishing new town is growing rapidly. It is situated on the San Joaquin and Sierra Nevada Railroad, and a more beautiful, as well as favorable location for a village could not have been selected," wrote an 1885 promotional booklet. In 2007, the Valley Springs depot still stands, the only remaining building of the railroad. (Courtesy Calaveras County Historical Society.)

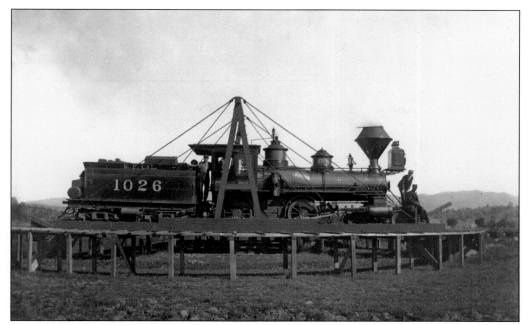

Sources identify this nearly 22-ton locomotive as a Baldwin-manufactured engine originally built in 1881 for the Oregonian Railway where it was the "Portland" or a Porter-built original purchase of the SJ&SN named the *Jacob Brack* for the Lodi farmer who instigated the railroad's creation. The narrow-gauge line was purchased by the Southern Pacific in the late 1880s. (Courtesy Calaveras County Historical Society.)

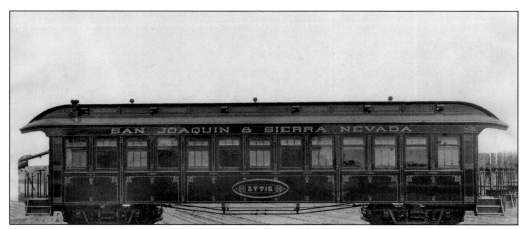

The showcase parlor car for the San Joaquin and Sierra Nevada, *Ettie*, the nickname of railroad president Birdsall's wife, was built in 1884 specifically for the SJ&SN by the legendary Carter Brothers Company in Alameda County. "It is a beautiful specimen of California workmanship," wrote the *Valley Review*, "[and] speaks well for the skill of our home mechanics." (Courtesy Calaveras County Historical Society.)

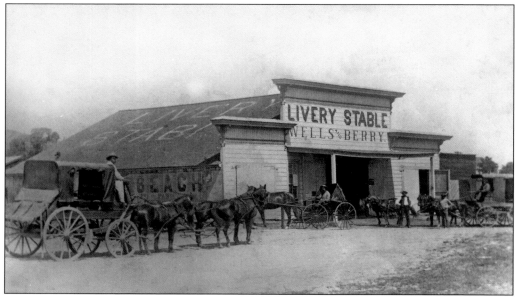

The Wells and Berry livery stable, founded by William Wells and Dave Berry, in the late 1880s, later became known as the Longley and Berry livery stable, a building that survived the 1895 Valley Springs fire that destroyed most of the business district. Stage and freight driver Bert Raggio is at the left in this *c.* 1890 photograph. (Courtesy Calaveras County Historical Society.)

The Pattee Brothers freight team heads from Valley Springs to the Penn Mine in Campo Seco as John K. Pattee Jr., standing in front on the ground, supervises the operation in this photograph, taken about 1890. (Courtesy Calaveras County Historical Society.)

With John Pliler and Joshua Lillie taking over from T. J. French in 1918, Pliler and Lillie began its reign as the major store in Valley Springs until the late 20th century. This 1920s photograph shows the market's main attraction—the butcher shop. (Courtesy Calaveras County Archives.)

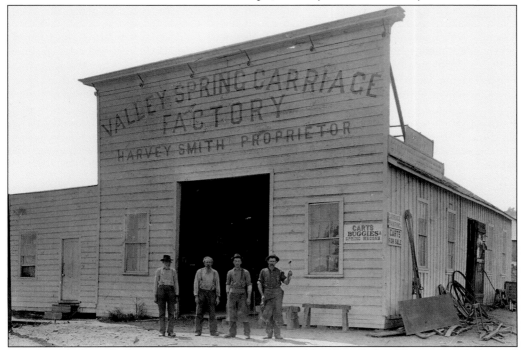

The first blacksmith shop in Valley Springs was owned by New Yorker Harvey Smith (second from left), shown with laborer R. L. Marsh (second from right) and Missouri-born blacksmith John Brown (right). Smith's father, Harvey Smith Sr., may be the elderly man to the far left in this 1885 photograph. (Courtesy Calaveras County Historical Society.)

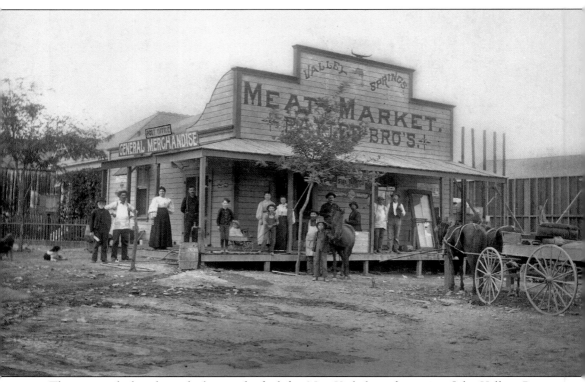

The man with the white whiskers to the far left is New York–born forty-niner John Kellogg Pattee. A prominent rancher, he eventually owned 700 acres, more than 3,000 sheep, and a wayside hotel at Pattee's Place, whose buildings would later move to the west and help create Valley Springs. When Joaquin Murietta's band stole horses from him, Pattee was part of the posse that chased down the robber. Pattee's prosperity was such that in 1870 he employed in his household not only a Chinese cook but also a female Norwegian servant. He lived on his ranch for 40-plus years before retiring to the town of Valley Springs, where he died in 1904. Sons John Jr. and Frank were the town's enterprising Pattee Brothers, and their market housed the first post office in Valley Springs. John Jr. would later also own the tanks and pipes that supplied Valley Springs with water. The photograph was taken in 1885. (Courtesy Calaveras County Historical Society.)

Students at the Spring Valley School pose with their teacher, Bertha Southworth (far left, holding book), in this 1908 class picture. The Spring Valley School was established in 1866 at Pattee's Place before moving just east of Mountain Gate when Valley Springs came into existence. (Courtesy Jack and Jackie Seibold/Schwoerer family.)

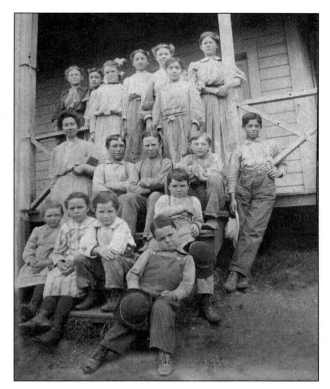

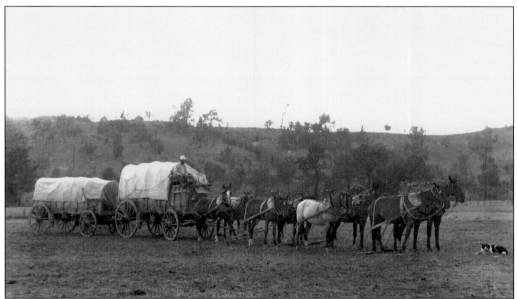

Teamster W.A. Titherington stops and poses for a photograph while hauling freight in the Jenny Lind area in 1875. With the advent of the automobile in the early 1900s, Titherington was constantly getting into accidents caused by the new machines frightening his horses. Trains, autos, and trucks would eventually put an end to the horse-drawn stage and freight lines. (Courtesy Calaveras County Archives.)

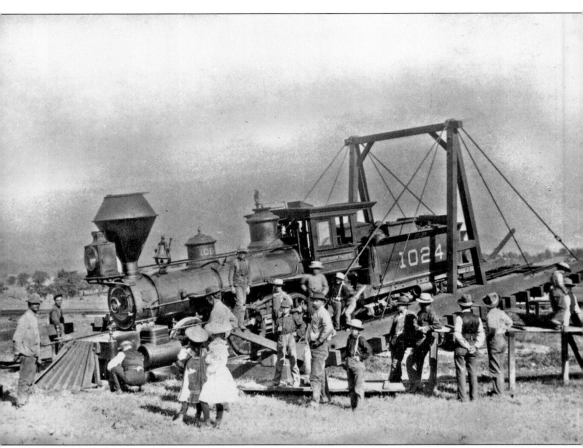

Named for Ben F. Langford, the area's powerful California state senator in the 1880s, this 18-ton, Porter-built locomotive slipped off the turntable at Valley Springs in 1902, two years before the railroad went standard gauge. In the mid-1920s, the line was extended to the Calaveras Cement plant at Kentucky House near San Andreas and a temporary line was also built north from Valley Springs to transport the materials needed to construct Pardee Dam. Passenger traffic was finally halted in the early 1930s. By the time Calaveras Cement closed shop in the early 1980s, and the train line ceased operation, the two enterprises together had also helped build the San Francisco–Oakland Bay Bridge, McClellan Air Fore Base and Travis Air Force Base, the San Francisco Airport, and numerous Central Valley dams. (Courtesy Calaveras County Historical Society.)

A few West Calaveras pioneers were veterans of the Mexican War, many more served during the Civil War, largely on the Union side but also a handful for the Confederacy. This 1917 photograph depicts the Valley Springs depot filled with residents, including a boy and his dog, bidding farewell to local enlistees of World War I. (Courtesy Calaveras County Historical Society.)

The business district in Valley Springs was along California Street (now State Highway 12). The town's strategic location for travelers is seen in the types of businesses that sprang up. At the center of this c. 1920 photograph is the first location of Pete's Place, the watering hole owned by former jockey J. W. "Pete" Ormes. (Courtesy Calaveras County Historical Society.)

On November 4, 1933, Ormes held a grand opening for his new location down the street and Pete's Cafe became the social center of Valley Springs. Along with food, drink, and dance bands, illegal gambling and notorious women were also available. An elderly Pete was brutally murdered in his café in the 1970s when robbers demanded money, and the diminutive Pete refused. (Courtesy Calaveras County Historical Society.)

PETE'S CAFE

In Calaveras County
 There's a town called Valley Springs
And everyone that stops there
 Its praises loudly sings

Its on the way to the Big Trees
 And the famous Mother Lode,
In the land of Gold and Romance
 On the trail that Bret Harte rode.

Whenever you are passing,
 Don't fail to stop at PETE'S,
Its sure one swell restaurant
 And the Home of Damn good Eats.

The festive grand opening of Pete's Café featured a commemorative brochure and included a poem, whose first three stanzas are shown. Subsequent lines read, "And perhaps when it is lawful / They'll sell a little booze." By all accounts, Pete did not wait for his license—and his café became the source for many of the newest legends of West Calaveras. (Courtesy Society for the Preservation of West Calaveras History.)

Nine

OLD CALAVERAS MADE NEW

During the first few decades of the 20th century, Calaveras, one of California's original counties, was often nostalgically referred to as "Old Calaveras." Today there is a "New Calaveras" that strives to bring together the best of the past with progress and hope for the future.

Until recently, Northern Calaveras lagged behind the growth of areas in the southern part of the county such as Angels Camp and Murphys. Despite the creation of the Tri-Dam recreational area in the early 1960s with the building of Camanche Reservoir and the expansion of Hogan and Pardee Reservoirs, and the new home sites of the Rancho Calaveras subdivision in the late 1960s and other subsequent housing developments, the entire county's population reached just 20,710 by 1980. Northern Calaveras, outside San Andreas with its center of county government, was a place people went through, not to.

That changed at the dawn of the 21st century. Attracted by its beautiful landscape and country living, visitors became increasingly drawn to quaint, small towns such as Mokelumne Hill and Mountain Ranch, West Point and Glencoe, Campo Seco and Paloma, Jenny Lind and Rail Road Flat. Looking for a more pastoral lifestyle, many chose new addresses to call home in places such as Valley Springs, Burson, and Wallace from which they might commute to work in cities as far away as Sacramento. Even retired and rescued exotic animals arrived, as the world-renowned Performing Animal Welfare Society (PAWS) chose vast acreage adjacent to San Andreas for its sanctuary. In 2000, a population of 40,554 made Calaveras the eighth-fastest growing of the state's 58 counties in the 1990s.

Today golf courses, residential developments, and second homes sprout amidst the wine grapes and olive orchards, cattle and sheep ranches, and pristine open space. Boating, fishing and camping, hiking and biking, have replaced mining and logging. Yet still today, witnessing growth unprecedented since the days of the Gold Rush, Northern Calaveras relies on its history as a touchstone of its essentially rural character.

Today hikers and other nature lovers from throughout California and the West come to Northern Calaveras to enjoy the wildflowers and other spectacular scenery along the Mokelumne Coast to Crest Trail, shown as it winds through the Camanche Watershed. (Courtesy East Bay Municipal Utility District.)

Ettie, seen in 1885 in the previous chapter, was sold after the railroad went standard gauge and was eventually purchased in 1927 by the famed White Pass and Yukon Route narrow-gauge railway in Skagway, Alaska. Now called the *Lake Aishihik*, the rail car was still carrying passengers every day as of this 2006 photograph. (Photograph by Sal Manna; courtesy Society for the Preservation of West Calaveras History.)

A water-skier enjoys one of the many sporting opportunities at New Hogan Reservoir, one of the three man-made lakes that form the Tri-Dam recreational area in West Calaveras. (Photograph by Rocio Miller; courtesy the *Valley Springs News*.)

Calaveras County is made up of small, tight-knit but welcoming communities. Annual festive events such as Lumberjack Days in West Point, shown, are important threads that bind together residents new and old, and remind everyone of their shared heritage. (Photograph by Lorene Landreth.)

Discover Thousands of Local History Books Featuring Millions of Vintage Images

Arcadia Publishing, the leading local history publisher in the United States, is committed to making history accessible and meaningful through publishing books that celebrate and preserve the heritage of America's people and places.

Find more books like this at
www.arcadiapublishing.com

Search for your hometown history, your old stomping grounds, and even your favorite sports team.

Consistent with our mission to preserve history on a local level, this book was printed in South Carolina on American-made paper and manufactured entirely in the United States. Products carrying the accredited Forest Stewardship Council (FSC) label are printed on 100 percent FSC-certified paper.

MADE IN THE USA